ROSWELL
HISTORY, HAUNTS AND LEGENDS

DIANNA AVENA

Haunted
America

Published by Haunted America
A Division of The History Press
Charleston, SC 29403
www.historypress.net

Cover design by Marshall Hudson.

All photos courtesy of the author unless otherwise stated.

First published 2007
Second printing 2008
Third printing 2011
Fourth printing 2011
Fifth printing 2013

Manufactured in the United States

ISBN 978.1.59629.308.3

Library of Congress Cataloging-in-Publication Data

Avena, Dianna.
Roswell : history, haunts and legends / Dianna Avena.
p. cm.
ISBN 978-1-59629-308-3 (alk. paper)
1. Ghosts--Georgia--Roswell. 2. Haunted places--Georgia--Roswell. I. Title.
BF1472.U6A98 2007
133.109758'23--dc22
2007025488

ROSWELL

To my husband, Joseph J. Avena, who continues to help show me that I can do all that I fear I cannot.

Contents

Foreword 9
Acknowledgements 11
Introduction 13

1. Some Roswell History…And Why Is Roswell So Haunted? 17
2. Lost Mill Workers of Roswell Monument,
 the Roswell Mill and Its Forgotten Ruins 22
3. Bulloch Hall 32
4. The Roswell White House 41
5. Mimosa Hall 44
6. The Intersection's Apparition 46
7. Jack's Old Cottage 49
8. Barrington Hall 52
9. Founders Cemetery 60
10. Katherine's Cottage—Fire in the Walls 70
11. Old Bricks 73
12. Voila Hair Salon 80
13. House with the Young Woman Rocking in the Chairs 86
14. Flame Tree Glass and Chaplin's 89
15. Creepy House and Abandoned Restaurant 92
16. Public House and Adjoining Buildings 103
17. The Dom House 117

Conclusion 123
About the Author 125

Foreword

R oswell, Georgia, is one of hundreds of small, quaint towns that dot the landscape of the South. Located just a short distance north of the city of Atlanta, it is a place that is rife with beauty, history and hauntings!

It is quite evident that Dianna Avena loves Roswell. She makes her home there with her family and she operates the Roswell Ghost Tour, a labor of love that acquaints visitors not only with the town's rich history, but also with its reportedly haunted reputation.

I first took the Roswell Ghost Tour during the fall of 2006. The autumn night was damp, chilly and overcast. A brisk wind sang through giant oak trees and autumn leaves danced and rustled all around. What a perfect evening to hear about spirits and visit haunted places!

Dianna led our group, numbering about twenty to twenty-five, on a mile-long journey through Roswell. Not only is she a breathtakingly beautiful lady, she is eloquent as well, and her passion for Roswell's history and its ghosts is instantly apparent.

The visit to Founders Cemetery is especially spooky, and ending the tour at "The Creepy House" left me feeling like I had certainly "met" some of the specters that haunt Roswell.

As a psychic, medium and paranormal investigator, I always hope to have my own personal experiences when I "hunt" for ghosts. And I had several during the Roswell Ghost Tour. Someone—or something— nudged my leg outside one of the buildings, moments before Dianna told us that, on earlier tours, a little girl who "haunts" the building often grabs

the legs of those taking the tour. Later, as we were walking to another location, an unseen hand tugged at the back of my shirt! Perhaps it was just my imagination, but I could have sworn that, several times, I saw faces of Roswell's long-dead residents gazing out at me from many of the darkened windows of houses and other buildings.

It came as no surprise to me when I heard that Dianna was writing a book about Roswell. Who better to tell its stories and add her own uni_ue blend of "sitting around the campfire" spookiness to the tales?

No visit to the Atlanta area is complete without planning an evening to enjoy the Roswell Ghost Tour. Keep in mind that even our ghosts and goblins here in the South will welcome you with their own "sixth sense" of Southern hospitality!

Until your travel plans call for a visit to Georgia, sit back and enjoy a virtual tour of Roswell as you read *Roswell: History, Haunts and Legends*.

Chip Coffey
Psychic, Medium and Paranormal Investigator
www.chipcoffey.com

Acknowledgements

My sincere appreciation goes to the following: Joe Avena; Jim, Trevor and Joey; Ryan "Ponyboy" Eldridge and Tim Senay; Roswell Historical Society; Historic Roswell Convention and Visitor's Bureau; Bulloch Hall; Barrington Hall; Chip Coffey; Historic Ghost Watch and Investigation; Georgia Ghost Society; Jack Richards; John Zaffis; Darkness on the Edge of Town Radio Show; J. Christopher's restaurant, which currently occupies the old Public House restaurant; Flame Tree Glass; Michael Hitt; Voila Salon; Thomas Tolbert; Tyra and Steve Vasche; and a particular thanks to Denise Eichhorn and Kristina Palson.

Additionally, I would like to thank the tour attendees and fellow paranormal investigators who supplied their firsthand accounts for this book, residents of Historic Roswell and last, but certainly not least, the nonliving residents of Historic Roswell who continue to welcome us and show us their presence.

Introduction

I have been a resident of Roswell, Georgia, since 1989. I grew up as an air force brat, which meant I moved around quite often, never staying in a particular location for longer than three years. I often meet other military brats who say they thought their experiences of moving around a lot were great fun. When I look back, I can appreciate the various places I lived, yet throughout my childhood I yearned to be one of those kids who was still friends with someone she went to preschool with. I vowed to myself that when I grew up and had a say in things, I would pick a great city to live in, where I would be happy to plant roots and stay. I wanted my kids to have a different experience—to love their hometown as much as I would love this "chosen" city—and I wanted them to attend high school with many friends that they'd known since preschool.

Well, I have accomplished that. I found the dream city when I became a young adult and had a say in where I called home. Roswell is twenty miles north of downtown Atlanta and it is currently the sixth largest city in Georgia, having a population at the time of this publication of around ninety-four thousand. The Roswell Historic District offers 640 acres of vintage homes, historic sites, museums, monuments, churches and cemeteries, with 122 acres listed on the National Register of Historic Places. Roswell is the home of many corporations' headquarters and booming high-tech and industry businesses, yet it manages to keep a small-town feel with a great sense of community and Southern hospitality. Roswell boasts a nationally recognized and award-winning Parks and

Recreation Department including eighteen parks with 800 acres of active and passive park land and facilities. Roswell ranked third in the new book *Best Places to Raise Your Family: The Top 100 Affordable Communities in the U.S.* Our city received a mention on ABC's *Oprah Winfrey Show* as one of the best small towns in America. Roswell has also been ranked one of the safest cities to live in the United States according to city crime rankings.

If I want the big city life, I don't have far to go to downtown Atla a. I can find culture, great shopping and restaurants all within a short drive, although we also have plenty of it here in our own backyard. Our town square is routinely the host of various festivals for the arts, music, food, storytelling, crafts, entertainment and health fairs. If I feel like hiking, camping or fishing, a short drive will have me in the thick of nature in no time. I also need to have my beach time on occasion, and again, not far away. I can hit Georgia's coast in four hours. The public school system can't be beat here and beautiful public parks abound. Roswell's charm and interesting history continually draw me in. Greek Revival architecture combined with a lot of New England influences make this city very unique.

I met my amazing husband here in Roswell. We have three marvelous sons and they were each born in the same hospital in Roswell, Georgia. We are still in the same school district that the very first one (now a teenager) began kindergarten in. This is home for me; this is home for my family.

I attended Roswell's ghost tour in 2000 when it had just begun. At that time it was called Roswell Ghost Talk Ghost Walk and was owned by Jack Richards. Jack is a great friend to us and is quite an accomplished man. He pioneered the ghost tour industry decades ago in Savannah, Georgia, creating the very first ghost tour there named Savannah Ghost Talk Ghost Walk. He later moved to Roswell where he lived and worked in the Historic Roswell Mill Village. As his friends and neighbors learned about the ghost tour he had started in Savannah, they couldn't help but inform him of the ghostly goings-on they had experienced in their homes and businesses in Roswell. It didn't take long for Jack to decide that Roswell was undoubtedly a paranormally active place as well, and it would be a great idea to start a ghost tour here.

My husband, my sons and I attended the Roswell Ghost Talk Ghost Walk several times before I asked Jack if I could become a guide for him. I couldn't get enough of the ghostly stories. I was amazed at how the stories were all current ones unlike those I'd heard at other cities' ghost tours. Many of those were decades and decades, even centuries old, and were most likely embellished over the years. They were more "legends" and campfire ghost stories than true paranormal experiences in my opinion.

Dianna Avena. *Photo courtesy of Adam Blai.*

The fact that Roswell Ghost Talk Ghost Walk's stories were all current made the tour that much more intriguing to us. Also, there has always been a strong desire to debunk the experiences, find out if there are natural reasons to explain away anything that seems unexplainable. If there are natural reasons for certain phenomena, then the tour does not incorporate them as ghost stories to share. Also, newer stories are not added, not deemed worthy, unless several different people over several different days or nights experience the same anomaly or paranormal activity. I also recall that I learned much of Roswell's interesting history solely by attending the ghost tour. Although I had lived in Roswell for a dozen years, I honestly didn't know a fraction of the history until I took that first tour.

I began as the main guide in 2004 and dove in headfirst into all things paranormal. My husband, Joe, convinced me that we could take over the tour. In late 2005 the timing was also right for Jack Richards, so we purchased the tour from him and renamed it Roswell Ghost Tour. I have become an avid paranormal investigator and have been featured on television shows and documentaries. I am a frequent guest on radio programs and a public speaker on the subject of the paranormal. In addition, I have had the privilege of performing paranormal investigations with respected teams at many of Roswell's haunted locations. We have experienced firsthand the hauntings at these locations and have no doubt that some of Roswell's past inhabitants have no desire to leave this great city.

Welcome to my favorite city in the world. I assure you it's worth a trip here—and you may never want to leave either.

1.

Some Roswell History…And Why Is Roswell So Haunted?

Originally from Windsor, Connecticut, Roswell King arrived in Georgia in 1788 at the age of twenty-three. He quickly established himself as a commission broker and dealer in cotton, lumber and rice in Darien, Georgia. He was named surveyor of Glynn County in 1793 and married Catherine Barrington in 1792. They went on to have nine children.

Later, in the early 1830s, Roswell King moved farther south on horseback. The discovery of gold in north Georgia had prompted him to investigate this area. He traveled down some Cherokee Indian trails by Vickery Creek leading into the Chattahoochee River (referred to by the Cherokee Indians as "River of the Painted Rock"). The Cherokee inhabited this area north of the Chattahoochee River, an area they once referred to as "Enchanted Land," until 1838, when they were removed to land beyond the Mississippi River. At the time of Roswell King's arrival, the nearby Chattahoochee River served as a boundary between enemy nations—the Cherokee on the north side of the river and the Muskogee on the other side. The white man was forbidden on this land originally, but laws that enforced this proclamation were often ignored and many treaties were broken.

In 1828, Roswell King's intention was to investigate business possibilities for the Bank of Darien. However, he recognized Vickery Creek as being a great natural resource for building a textile mill, so that's what he did. Once the Cherokee Indians were removed, he bought up many acres of land around Vickery Creek from white winners of a land lottery. He brought

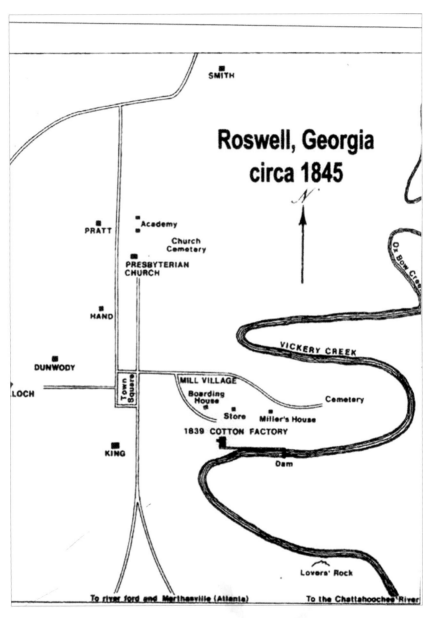

Map of Old Roswell and the Historic Mill Village. *Courtesy of Michael Hitt.*

several other wealthy families with him, all wanting to escape the diseases and heat of coastal Georgia living at the time, and they helped him to establish Roswell. With him, Roswell King brought his sons Barrington and Ralph, and they helped to build the mill complex, although it was mostly built by King's slaves. The mill was incorporated in 1839 as the Roswell Manufacturing Company in Cobb County. Roswell's family members and his family friends (the Bullochs, Dunwodys, Pratts and Smiths) all lived on one side of the main intersection in Roswell in their elegant mansions, and poor millworkers and slaves lived on the other side of the intersection, along what is now referred to as the Historic Mill Village.

Roswell King died in 1844 when he was seventy-eight years old, so he wasn't able to witness the incorporation of the town of Roswell, which didn't occur until February 16, 1854. King's wife died in 1839 and never lived in Roswell herself. Roswell King and his sons planned the little village that grew to become one of the ten largest cities in Georgia. They designed the town with a central square, mill village, church and stores, with architecture and layout influenced by their New England roots. By 1860 the Roswell Manufacturing Company had tripled its capital and doubled the size of the mill complex and its number of employees. It produced tents, cotton cloth, rope and yarn, and was the largest cotton mill in north Georgia at that time. Roswell's son, Barrington King, deserves much credit in the successful operations of the Roswell Manufacturing Company.

Why is Roswell so haunted? There are a few reasons as to why Roswell seems to be particularly active, or "haunted." The gorge that goes down to Vickery Creek is about three hundred feet deep at some points. There has been archaeological evidence within the gorge that proves people have been living in the Roswell area for at least six thousand years. The longer you have people living, loving, working and dying in a particular location, the better chance you'll have of astral debris. Also, there is reportedly a large fault line that runs beneath Roswell, a characteristic which is generally known by paranormal researchers as a large contributor to paranormal activity; when fault lines move they emit a large amount of electromagnetic frequencies. It is also a common theory that more paranormal activity may be witnessed after a thunder and lightning storm. The theory is that a ghost or spirit can pull from that energy in the atmosphere to more easily manifest itself.

In addition, there was a strong emotional imprint in this area, particularly during the Civil War. Many loved ones were ripped apart,

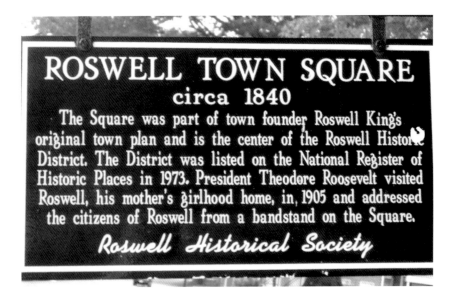

ROSWELL TOWN SQUARE
circa 1840
The Square was part of town founder Roswell King's original town plan and is the center of the Roswell Historic District. The District was listed on the National Register of Historic Places in 1973. President Theodore Roosevelt visited Roswell, his mother's girlhood home, in, 1905 and addressed the citizens of Roswell from a bandstand on the Square.
Roswell Historical Society

Historical marker at Roswell Town Square.

unable to find one another in life, and it appears many of them have returned to Roswell to reunite with those loved ones.

Why is any place haunted? Theories abound, and I feel that most of the ones I have heard can all be valid. I don't believe there is any one reason as to why a spirit remains here on earth. There is the theory that a spirit lingers behind to tend to unfinished business with loved ones. Maybe even just to check on loved ones. Another theory poses that a spirit may feel that a loved one cannot function without it, that it is needed by someone too much to be able to go on alone. Another theory relates to those that were killed in a very swift way; therefore they didn't see it coming, and they don't even realize they are dead. Another theory is that a spirit may fear divine retribution. If we have free will in life, do we also have free will in the afterlife? What if we believe in a heaven and a hell and we fear that our place will not be in heaven? Is it possible to avoid greeting our maker, and therefore we can simply choose not to?

Another type of haunting is referred to as a residual haunting. This is not what we'd call an "intelligent" haunting, where the ghost can interact with and be aware of our presence. A residual haunting is where the same apparition is witnessed going through the exact same motion in the same location over and over and over again. It is believed that it is simply an imprint of energy in

a location. When all the factors in the atmosphere are just right, the residual energy, or playback, can be witnessed—never changing.

One such example of this occurs right at the Roswell Town Square where we meet and end the Roswell Ghost Tour. Farther south of the square, about three hundred yards toward the Chattahoochee River, there used to sit a small house on the main street in the early 1900s. The house is long gone, and apartment buildings sit there today. There, in that little house, lived a mother and her adult daughter, and they were known around town as Blanche and Little Blanche, each of them named Blanche Lowe. Little Blanche worked at a brassiere factory in downtown Atlanta, but every Saturday night, Little Blanche and her mother would head downtown for a fancy dinner and a movie. They would get all dressed up and stand on the north end of the square, waiting for a taxi to take them downtown.

As mother Blanche got older, she suffered from Alzheimer's disease and Little Blanche worried about her mother leaving the house while she worked in Atlanta. She alleviated her worries by literally tying her mother to a chair when she left for work every day, and she would untie her once she got home at the end of the day. Mother Blanche had plenty of company as they had many dogs in the house, mostly greyhounds, since they both had a big heart and took in every stray that came their way. Unfortunately, one day mother Blanche had a deep scratch on her arm and it began to drip blood. This sent one of the dogs, and then all of the dogs, into a frenzy. Tragically, when Little Blanche arrived home on this day, she found their dogs had mauled her mother to death. It has been reported that on many a Saturday night, Blanche and Little Blanche can be seen in their best 1940s dresses as they wait for the taxi on the north end of Roswell Town Square.

Lost Mill Workers of Roswell Monument, the Roswell Mill and Its Forgotten Ruins

The Lost Mill Workers of Roswell Monument was erected in the summer of 2000 and is dedicated to the four hundred women and children who were charged with treason and sent north by Union troops during the Civil War. The Roswell Mills Camp #1547, Sons of Confederate Veterans, wanted to provide the City of Roswell with a monument to honor the memory of her most courageous citizens. It is located on the east side of Old Mill Park on Sloan Street, which is right in the middle of what is currently known as Historic Mill Village. The base is surmounted by a shattered Corinthian column, which symbolizes those lives that were torn apart under tragic circumstances. Each of the four sides of the column tells a bit of the chronology of events that took place during the Civil War. The granite monument stands ten feet high, and its shape was inspired by the monument marking the remains of Roswell's founder, Roswell King, in Founders Cemetery.

In May 1864, General William T. Sherman led three Union armies who began moving south from Chattanooga, Tennessee, to capture Atlanta. There were major battles occurring between opposing forces all the way to Kennesaw Mountain. On July 3, Confederate General Joseph E. Johnston retreated south from Kennesaw to trenches on the Chattahoochee River, known as the river line. Sherman sent four thousand mounted troops twelve miles up the river to outflank the Confederate army. Union General Kenner Garrard was in command of this flanking column. His mission was to capture Roswell's covered

Lost Mill Workers of Roswell Monument, the Roswell Mill and Its Forgotten Ruins

The Lost Mill Workers of Roswell Monument.

bridge, gaining a crossing point to threaten the Confederate position downstream. On July 5, this Union force battled with the Confederate cavalry that was guarding the road to Roswell, an area which is now GA 120. What developed was a three-mile running gun battle toward the bridge. James R. King, who was the grandson of Roswell King, instructed his Confederate soldiers to burn the bridge behind them to slow down the Union troops. Very near that bridge was the woolen mill.

The men who had been running the mill were sent off to fight, so the women remaining in Roswell took over the mill to keep it in operation and to earn money for themselves and their families. General William T. Sherman heard from General Kenner Garrard that the women were making the "Roswell Grey" material used for the Confederate soldiers' uniforms. He had his troops force the remaining Roswell residents out of the South, and the majority of them remained transplanted where they were sent. Then the troops burned down what they could of the mill buildings and many other homes and buildings throughout Roswell.

A French citizen by the name of Theophile Roche, who was a cotton mill employee, tried his best to salvage the mill from the Union's fiery rampage. In an attempt to feign neutrality, he flew a French flag over the mill's main building. Unfortunately, the letters CSA (Confederate States

Bridge over Vickery Creek.

Lost Mill Workers of Roswell Monument, the Roswell Mill and Its Forgotten Ruins

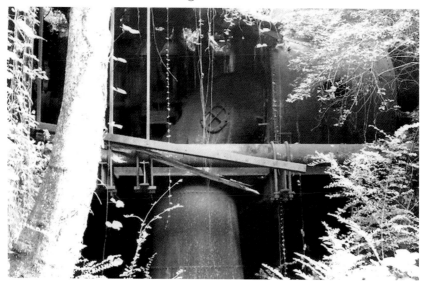

Old Roswell Mill ruins.

of America) were found on the material being produced by the mill. His tactic saved the mill for two days, but on July 7, once his claim of neutrality was discovered as false, General Sherman charged everyone remaining in the city of Roswell with treason.

This action even shocked people in the North and created a mystery that has endured to this day, for on July 7, 1864, Sherman reported to his superiors in Washington, "I have ordered General Garrard to arrest for treason all owners and employees, foreign and native (of the Roswell Mills), and send them under guard to Marietta, whence I will send them North."

Supposedly, families tried to hide within the mill's walls when the Union troops came through. Today, it isn't uncommon to hear screams coming from the now boarded up old machine shop, and there have been many reports of seeing women and children roaming about inside.

Not all of the women and children survived this exile, which generally led them north of the Ohio River. They were forced on foot to downtown Marietta where they were imprisoned for a short while before being led north in boxcars with just a few days' rations. They were very poor and had no means to return to their homes in Roswell.

Webb Garrison, former associate dean of Emory University and a leading expert on this incident, wrote the book *Atlanta and the War*. In it,

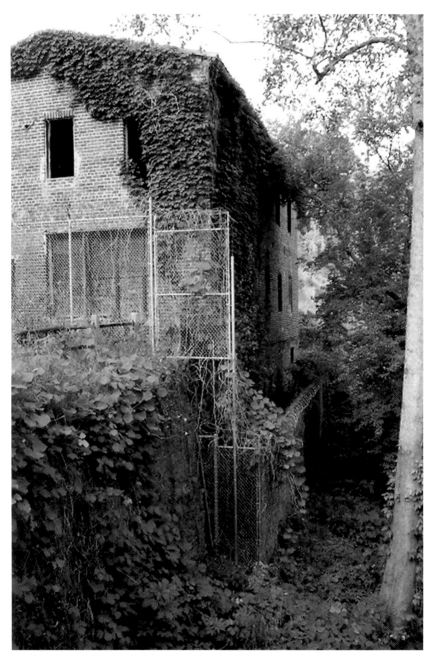

Old machine shop.

Lost Mill Workers of Roswell Monument, the Roswell Mill and Its Forgotten Ruins

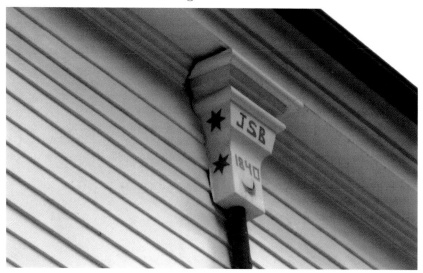

Masonic symbols found on Major James Bulloch's home. It is widely believed that the antebellum homes were not burned by Sherman's troops due to the fact that they each had symbols like these on their homes, and General Sherman himself was a Mason.

he says, "Incidents of this sort occurred repeatedly throughout the Civil War. Had the usual attitudes prevailed, the destruction of the industrial complex would have ended the matter. That it did not was due to the temperament and inclination of the man [Sherman]."

A Northern newspaper correspondent reported on the deportation, "Only think of it! Four hundred weeping and terrified Ellens, Susans and Maggies transported in springless and seatless army wagons, away from their loves and brothers of the sunny South, and all for the offense of weaving tent-cloth."

On July 19, 1864, General Thomas reported the arrival of four to five hundred mill hands, mostly women, in Marietta. Other documents indicate that an undetermined number of children accompanied their mothers. Webb Garrison writes of the women's arrival in Marietta, "For the military record, that closed the case in which women and children were illegally deported after having been charged with treason…Had the Roswell incident not been followed immediately by major military developments, it might have made a lasting impact upon opinion. In this century, few analysts have given it the emphasis it deserves. The women and children were never tried for the crime for which they were accused."

Roswell Mill ruins along Vickery Creek.

The Union troops occupied Roswell for twelve days in July 1864. They took up residence in many of the elegant mansions that had been abandoned when the homes' residents fled the area. It was said for a long time that Sherman's troops didn't burn down those big beautiful mansions simply because that is where they stayed while occupying Roswell, using the homes as headquarters and hospital spaces. But legend has it that General Sherman was a Mason, and these homes had the Mason's symbol atop their front doors, which is the main reason why the homes were left unharmed. Pilfered maybe, but not burned down.

We do know of one exceptional woman who had been working as a mill seamstress. Just days after Adeline Bagley Buice's husband left Roswell to fight in the war, she found out that she was pregnant. She survived the trip to the Chicago area, where she was sent from Marietta, and vowed she would someday get back to Roswell to find out if her husband had survived the war. It took her five years, but she and her daughter did make it back to Roswell to find that her husband had survived the war and he too had made it back to their city. Unfortunately, much to her dismay, he had presumed her dead and had remarried about a year before her arrival. Adeline Bagley Buice was buried in Forsyth County after her death where her grave is tended to by the Sons of Confederate Veterans.

Lost Mill Workers of Roswell Monument, the Roswell Mill and Its Forgotten Ruins

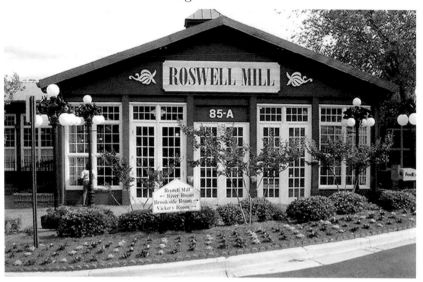

Roswell Mill as it looks today.

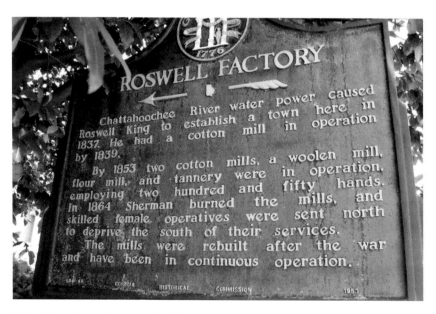

Historical marker at the Roswell Mill.

Roswell Mill ruins.

She was very much the exception. The majority of the women did not make it back to Roswell, and if the men in their lives survived the war and had made it back to Roswell, they had no way of finding out where their loved ones were. Their mothers, wives, sisters, daughters had vanished from Roswell due to General Sherman's actions, and most of them never saw these loved ones again in life. Have many of them returned to Roswell to find those lost loved ones?

The mill's ruins may be visited by a short hike along Vickery Creek. Old brick walls, brick walkways, forgotten brick chimneys and large steel gears, wheels and piping may still be seen. The 1853 machine shop is the only extant building of the original 1839 Roswell Manufacturing Company. It is a two-story brick building built in late Georgian style and has a brick cornice ornamenting the roofline.

As I speak of this area, particularly where the old mill's ruins are, I have to wonder if there is a residual haunting there, as opposed to an intelligent haunting. It happens quite often that I will hear stories from Roswell's residents of unexplainable activities, activities that we've already incorporated into our tour because of their frequency. The one story I hear the most is of the sounds heard amongst the mill's ruins.

Lost Mill Workers of Roswell Monument, the Roswell Mill and Its Forgotten Ruins

Many, many times, I've heard from residents or visitors to the area that if they are down amongst the mill's ruins, particularly after dark (which is not permitted), sounds of clanging can be heard. They are the sounds of metal hitting metal, as if someone is in the throes of heavy physical labor. Interspersed with these noises will come bloodcurdling screams, and no natural source for these sounds can be found by those hearing them.

My own husband had this experience. While attending Milton High School, after dark he and some friends were down in the area by Vickery Creek—where the ruins are—and heard exactly the same sounds that have been described by others over the years. He and his friends ran screaming from the area.

I find it interesting to note that a residual type of energy can be experienced at the mill's ruins. Occupational Safety and Health Administration laws were nonexistent back then. The millworkers were worked for long hours at a time in an unsafe environment. Injuries, sometimes as severe as having limbs torn from bodies, were not uncommon.

One of our very own guides, Ryan "Ponyboy" Eldridge, had an experience several hundred yards up from the ruins. At the spot along the street where we share the mill stories, he experienced an anomaly that was most definitely not one of a residual nature. Ryan writes:

> *The first time I was ever in Roswell was to take one of the tours, and it has offered me one of my most memorable paranormal experiences to this day. We were standing at the top of the staircase at Vickery Creek Park, and we were all listening as Dianna recounted stories about the old Roswell Mill. As she spoke I felt fingers brushing through my hair. They ran all the way down the side of my head, from front to back. Now that I've become a guide on the tour, it seems they've become friendlier with me than ever. I continue having experiences at that spot on an almost weekly basis!*

3.

Bulloch Hall

Bulloch Hall is one of the three main antebellum mansions that Roswell is fortunate to have. This grand home was built in 1840 for Major James Stephens Bulloch and his family. It is built in Greek Revival style and made of heart pine, an extremely hard and durable wood. Bulloch Hall has been described as one of the most significant houses in Georgia and one of the South's few examples of true temple-form architecture with a full pedimented portico. The floor plan is typical to the period, referred to as "4-square," and features a lofty center entrance hall with an equal number of rooms on each side. There are a staggering eleven fireplaces and a downstairs kitchen complete with a beehive oven.

Today, Bulloch Hall bears 142 trees on the Historic Tree Register. Major Bulloch himself had taken considerable care of the grounds. He had an arbor and planted 37 shade and fruit trees near the house. Osage orange trees were utilized because of their ability to discourage flies and rodents.

Bulloch Hall was handed down generation after generation within the Bulloch family until it went empty in the 1950s. It remained empty for a couple of decades until it was purchased by the City of Roswell in the 1970s and made into the museum that it is today. Tours are given seven days a week for those wanting to see what life was like in a Southern Greek Revival mansion in the mid-1800s. It has a working kitchen in the basement, very tall ceilings, beautiful gardens and tall trees, and reconstructed "slave quarters" on the property.

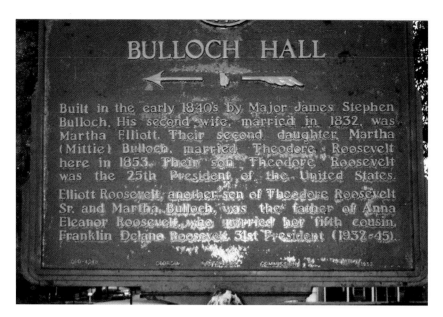

BULLOCH HALL

Built in the early 1840's by Major James Stephen Bulloch. His second wife, married in 1832, was Martha Elliott. Their second daughter, Martha (Mittie) Bulloch, married Theodore Roosevelt here in 1853. Their son, Theodore Roosevelt was the 25th President of the United States.

Elliott Roosevelt, another son of Theodore Roosevelt Sr. and Martha Bulloch, was the father of Anna Eleanor Roosevelt, who married her fifth cousin, Franklin Delano Roosevelt, 31st President (1932-45).

Historical marker at Bulloch Hall.

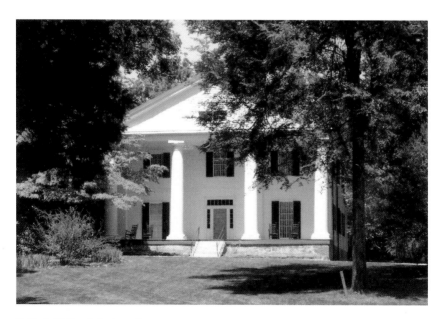

Bulloch Hall as it looks today.

Bulloch Hall was the childhood home of Mittie Bulloch. She was raised here from the age of five until she became a young adult and married Theodore Roosevelt Sr. in December of 1853. They went on to have a son named Teddy Roosevelt, our twenty-sixth president, who came to visit his mother's childhood home in 1905. Interestingly enough, Bulloch Hall has yet another tie to an American president. Mittie and Theodore had another son by the name of Elliot who fathered Eleanor Roosevelt. Eleanor of course married Franklin D. Roosevelt who was a distant cousin. She had a major impact on shaping the changing role of women in the nation and the White House. Her dedicated service in the area of human rights became legendary.

The Mittie and Theodore wedding was a major event in Roswell, as the wedding took place in this very home at Bulloch Hall. As you can imagine, it was quite a big deal to have the many Roosevelts coming down to little old Roswell; the city was hardly on the map at that time. An article was written all about the famous wedding by Margaret Mitchell no less, the famous author of the epic novel *Gone with the Wind*. She wrote the article for the *Atlanta Constitution* newspaper in June of 1923. This wedding was so significant to Roswell's history and to the history of Bulloch Hall that there is a reenactment in mid-December of every year. The reenactment is complete with Christmas decorations all throughout the home and local residents dressed in period costumes as they represent all the key players that were present at the original ceremony in 1853. What is interesting to many is that there have been multiple reports by these reenactors about unexplainable issues regarding the lit candles and electrical lighting during these events. They have stated that there may be six lit candles in a row, but some will blow out for no apparent reason. There are no drafts, no vents kicking on and no one (visible) running by them. They have even witnessed candles becoming lit all on their own. In addition, once lit, some candles become physically impossible to blow out.

We can't help but wonder if these events are connected to a well-known legend here in old Roswell. There have been many reports of a young black girl, around the age of fourteen, having been seen on Bulloch Hall's property. There is no formal documentation of this, but local legend has it that this young girl died in a well behind Bulloch Hall's main home some time in the mid-1800s. The well is still standing today, and there have been reports from our tour guides that sounds of a girl sobbing come from that very well. The cries are heard by all present at these times, usually after dark. According to this legend, the girl that fell in the well

Bulloch Hall

The well behind Bulloch Hall.

had a job at Bulloch Hall during her young life. Her job was to make the candles and tend to the candles and oil lamps within the home. Are the unexplainable candle and electrical issues this girl's way of showing us she is still at the property?

Stories involving mysterious electrical issues have been reported over the course of many years at Bulloch Hall. For instance, one fall night a guide was giving a tour and while standing in front of the house with `is tour group, he noticed that the attic light was on. He remarked out loud that he had never seen that light left on before. As the guide walked on to the next stop, he was approached by a woman who scurried up to him. She said that she was a docent at Bulloch Hall and she had personally turned off all of the appropriate lights, set the security system and locked up. She saw no reason for that light to be on. She called the tour owner the next morning to say that after the tour had finished, she drove by Bulloch Hall on the way home and was astonished to see that the light was no longer on. She was much too rattled to go inside and check anything out by herself, so she went home. She came in the next morning and entered the old home in the company of others. No one saw signs of anything or anyone having entered and the security system had never been triggered—or even disarmed—so they saw no way that someone could have turned the attic light on and then off.

I myself feel that I've had a paranormal experience or two at Bulloch Hall. A couple that lives next door to us in Roswell went out to dinner with my husband and me. We stopped by the front of Bulloch Hall on the way home to look around a bit. It's very beautiful at any time of day, but particularly after dark. There are a couple of lights at the tops of the columns that shine down on the front porch, as well as a couple on the grounds in the front of the home that shine up on the front. It's quite breathtaking to see the home in all its glory as you're driving up Bulloch Avenue, which dead-ends onto this grand property.

Once we got to the beginning of the driveway leading to Bulloch Hall, our female companion got a little unnerved and wouldn't get out of the car. She asked me to stay with her while the men got out and walked up to the front of the house. As we ladies sat in the car and watched, we noticed that as the men got closer to the porch, the drapes on the top right-hand window started to shake back and forth. I thought it must've been a vent nearby that kicked on, but we noticed it wasn't flowing uniformly; it was more like they were grasped in someone's fists and being shaken back and forth. As the men walked back toward the

car, the drapes stopped. We sat and watched for a few more minutes since the guys hadn't seen it, but we didn't see it happen again. The split second that our headlights came off of the house as we backed up to leave, the exterior lighting on the main house went off as well. I've since checked with some of the women who work at Bulloch Hall and found that the lights are on a timer to go off in the wee hours of the morning. This occurred at exactly 10:37 p.m.

On another night, I had family visiting from out of town and I wanted to show them the beauty of this breathtaking home and property. It was again following dinner and quite dark outside at the time. There were six of us in our car and we stopped at the end of the driveway. Several of us got out of the car with our cameras to take some photos. I snapped a photo with my digital camera and caught a large ball of light that I did not see with my naked eye. In my photo, the light appeared to be high above Bulloch Hall's rooftop. When my mother took a photo with her camera, she caught the ball of light too, only this time it was much closer to us. My sister then took a photo with her digital camera, and again, the white ball of light was in the frame, but much closer to us still. We all began to feel a sudden drop in temperature and were unnerved enough to climb into the car to leave! My window was open where I sat in the front seat of the car and I stuck my camera out the window to snap one last shot. As I pulled my camera inside the car to check out the latest photo, we all remarked about the sudden drop in temperature within the car as I noticed that the white ball of light had nearly engulfed the entire frame of the last photo. Also at that same time, my sister in the back of the car asked aloud, "Who has coffee?" None of us had coffee, yet she swore that it was as if freshly ground coffee beans were being held underneath her nose—the smell of coffee was that strong to her. None of us smelled anything like what she described.

There have been several people over different nights who have seen a young boy in knickers running around the front lawn picking up sticks or running along a white fence on the property. There was one tour attendee who said she felt a child trying to grab at her hand while she was listening to the tour guide. She looked down expecting to see a child who had mistaken her for his mother, only to see this young boy run out onto the front lawn and vanish into the night. Also, there have been reports by several people that the sounds of men's voices can be heard by the reconstructed slaves' quarters on the property, yet there is no one else around.

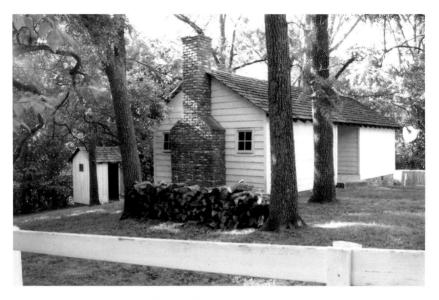

Reconstructed slave quarters at Bulloch Hall.

One night a longtime worker at the Bulloch Hall Museum was on the upstairs level and something caught her eye on the stairwell as she passed through the hall. As it was after hours, no one else was in the house. She turned toward the stairwell to see the tall, dark figure of a man on the stairs. She noted that he had on a long, dark coat, a top hat and had a bearded face. She ran after the figure, at which point he vanished.

This same employee tells of another inexplicable occurrence that happened when she and one other person were in the house after museum hours. She said that she remarked out loud that she didn't believe the house was haunted. Just then, a loud banging occurred that made the two of them bolt out the front door. Eventually, they decided they'd try to find a natural reason for the loud noise. She said it sounded like large iron skillets had been dropped on the floor, one after another, but they found nothing on any of the floors.

It's common knowledge to those that work at Bulloch Hall that the rocking chairs on the front porch will routinely be seen rocking by themselves. I have seen this myself on two separate occasions while I had a tour group at that stop. We watched the chair, expecting the rocking to slow down and stop—this didn't happen. In fact, there were times when the rocking chair appeared to pick up speed instead of slowly stopping.

Interior of reconstructed slave quarters at Bulloch Hall.

I have taken the opportunity to sit in this particular chair in broad daylight. I immediately felt as though someone's face was directly in front of me, staring at me, as if I absolutely had taken a seat in their rocking chair. I got up and sat in another, where I felt quite at peace and welcomed.

Several of Roswell's police report that for many years, particularly during the years when Bulloch Hall was abandoned, they would get calls that the security system was going off or calls from people saying th 'd seen "intruders" inside the home. The police would constantly be sent out there to investigate only to find that there was no one inside and no signs of a break-in.

One night while giving a tour, after the stories were all told and the ghost tour guide proceeded to walk on to the next stop, she was abruptly stopped by one of the tour-goers and asked who currently lived in the home. The guide reiterated the fact that no one resided there any longer and hadn't for many decades. She again told her that it was a museum and no one was inside after hours. This tour-goer stopped everyone in their tracks when she told of seeing a family in the attic window many times prior to this particular night. She explained that she had lived in the area for a few months and she liked to jog through a street that took her by the front of Bulloch Hall's property. She stated that she kept seeing this family stare out at her. She had tried to wave to be friendly at first, but the "family" would never wave back; they only stood and stared. The tour-goer was really hoping to find out from the Roswell Ghost Tour guide about the family because she could not figure out what was up with these very odd people.

Bulloch Hall's curator has a journal written by a young woman in the Bulloch family, from the mid-1800s. She was rooming in one of the bedrooms with a window overlooking the back of the home. In her journal she wrote of seeing a procession of slaves with their lit candles moving through the trees in the middle of the night behind the home. That is when the slaves buried their dead, in the quiet and stillness of the night. What this journal entry tells us is that there may be countless numbers of slaves buried in unmarked graves on Bulloch Hall's property amongst the trees behind the main home and behind the well.

4.

The Roswell White House

This was the Victorian-style home of Emily Frances Gordy Dolvin (1912–2006), aunt to President Jimmy Carter. This home, circa 1875, was originally designed as a typical "salt box" home. The Victorian-style porch was added on to the home in 1905.

Emily was commonly referred to as "Aunt Sissy." She was an educator, political campaigner, historic preservationist and civic leader in the state of Georgia. Her sister, Lillian Gordy Carter, was Jimmy Carter's mother. Emily died of congestive heart failure on December 2, 2006, in her Roswell home on Bulloch Avenue—where it neighbors Bulloch Hall—after having lived in this home for several decades. Emily was in her mid-nineties when she died. Her home is referred to as the Roswell White House because supposedly Jimmy Carter's presidential campaign began out of her house.

Emily had a very full and productive life, one that contributed to our city of Roswell in a profound way and will be felt for generations to come. She assisted in organizing the Roswell Youth Recreation Committee, which helped to create the Roswell Recreation and Parks Department. When the Roswell Historical Society was established in 1971, Emily was the inaugural chairperson. This society is responsible for the black and white historical markers seen throughout Historic Roswell (several of which are pictured in this publication). Whenever I stop to notice these signs, I think of Emily.

In 1970, Emily Dolvin was a staff member, delegate and host for the Georgia Democratic Party and a volunteer coordinator for Carter's gubernatorial campaigns. She was also the reception chairperson for

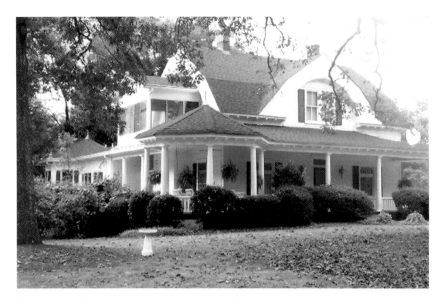

The Roswell White House. Also known as the W.J. Dolvin House.

Carter's inauguration as governor of Georgia in 1971. Emily served as a member of the Commission on the Status of Women from August 1972 to April 1974. She campaigned as a member of the family in the Peanut Brigade. In 1976, *Time* magazine described her as a "tiny, stylishly dressed, white-haired dynamo" and the secret weapon of Carter's campaign. Later, she served as coordinator of docents for the Carter Center when it opened its door in 1986. In 2004, near the end of her active life, she was listed as one of Roswell's Fifteen Most Remarkable Citizens.

While Dolvin was living, any time I would give the tour of her home and see a car pull into her driveway, I'd try to sneak a peek to see if President Jimmy Carter was paying his aunt a visit or if it was Emily herself. One night I did get the privilege of seeing Emily as I saw a car of three people pull into her driveway. As we walked by we saw a man and woman who appeared to be in their mid-fifties walk Emily from the car up to her home.

When we stopped at our next stop, at the end of Bulloch Avenue, we saw that that couple was walking toward us with their dog. The woman spotted my "Roswell Ghost Tour" shirt and approached me very excitedly. She introduced herself as Emily's daughter; she had grown up in that home we had just passed, but she had since moved out of state. She was in town visiting her mother and childhood home with her husband. Upon seeing my shirt, she wanted to ask me if I was aware that Bulloch Hall was haunted. The tour group chuckled as we had just spent over twenty minutes at Bulloch

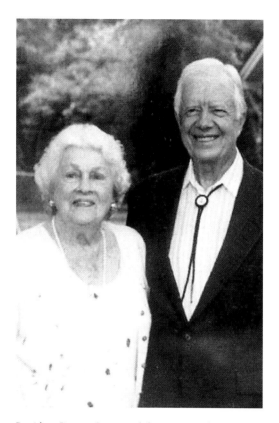

President Jimmy Carter with his Aunt Emily Dolvin in 1980 while visiting her in Roswell. *Courtesy of Midge Schultz, Emily's daughter.*

Hall where I told them of many unexplainable events there. This woman proceeded to tell me of a time when she was in elementary school, living at Roswell White House. At that time she was a Girl Scout and another Girl Scout friend of hers was living at Bulloch Hall. The friend hosted a Girl Scout sleepover at Bulloch Hall, so the home was filled with many young girls and a few of their mothers. As they were setting up their sleeping bags on the main floor, many loud footsteps were heard coming from somewhere upstairs. A couple of the brave mothers decided they needed to make sure they didn't have an intruder, so they proceeded upstairs to check it out. They scoured the upper floor and continued to hear the footsteps above their heads, coming from the attic. They yelled upstairs for the intruder to come out and the sounds abruptly stopped. The women finally proceeded upstairs to the attic to see if possibly some of the young girls' boyfriends had entered to try to spook them. They found no one up there and were quite spooked themselves when they realized there had been no way for anyone to leave the attic area without passing by them on the very stairwell they climbed to get there.

So Emily Dolvin's daughter wanted to let me in on the fact that Bulloch Hall had at least one ghost in its attic. She stated she didn't believe her own childhood home was haunted, but if Emily ever comes back to visit, I sure hope she comes to say hello to us. She sounds like she was quite an interesting lady.

5.

Mimosa Hall

Mimosa Hall was built in 1840 for John Dunwody and his wife Jane Bulloch. It is believed to have been designed by Willis Call, a Connecticut architect. Mimosa Hall was built next to Bulloch Hall where it was originally called Dunwody Hall. When the building of the home was complete in 1842, it happened to be in the middle of December. The Dunwodys decided to have a housewarming and Christmas party combined. In the haste to clean up all the debris around the house in preparation for this party, the workers threw a lot of that debris down the chimney. When the Dunwodys lit a fire in their fireplace during the course of the party, some of the cinders popped out onto the chimney during the party and wound up burning the house down. The home was rebuilt in 1847, this time with brick and then stuccoed over and scored to look like stone. It was renamed Phoenix Hall at that time, in reference to the phoenix rising from the ashes. When General Andrew Jackson Hansell and his wife saw all the many mimosa trees on the property while living there beginning in 1869, they renamed it yet again, this time to Mimosa Hall, as it is referred to today.

As an aside, many people will say that they do not necessarily believe in ghosts due to the simple fact that they have never seen one themselves. What most people are not aware of is that there are multiple ways of experiencing a haunting, or a ghost. There is the first way we all think of, which is seeing a ghost with our eyes. This is very rare and is referred to as clairvoyance. There is also the possibility of hearing a ghost. This would include hearing footsteps, music, tappings or voices, referred to as clairaudience. Additionally, one could

Mimosa Hall as it looks today.

smell a ghost, an ability which is referred to as clairnatience. There are many reports of people having smelled their dead grandfathers' cigar smoke where no one was smoking, or of smelling a dead person's very particular perfume or cologne smell. Smells of certain foods or flowers at locations where no source can be found have also been reported. Generally speaking, putrid smells at a haunted location with no natural source are a very negative sign, an indication of something evil. Luckily, none have been reported, that any of us are aware of, in Roswell! A final way that a person can experience a ghost is by feeling them with their physical senses, an ability referred to as clairsentience. This would include feeling cold spots, hot spots, tugs on clothing, embraces by something unseen, taps on shoulders, etc.

Here at Mimosa Hall, there have been many reports by visitors who are apparently clairnatients. These people will inadvertently begin running around frantically trying to find what is burning. They sincerely believe that they smell burning embers, while others on the property do not smell anything like what they are describing.

A previous ghost tour guide approached an employee who worked for the residents of Mimosa Hall. She introduced herself as being with the ghost tour and received an interesting response from this member of the housecleaning crew. She responded, "No ghosts here! I don't care about the noises in the attic. I don't care about the man in the cape on the stairs!"

Maybe one day we'll find out who the man in the cape on the stairs is!

6.

The Intersection's Apparition

As the main tour guide for Roswell Ghost Tours since 2004, I will often get asked if I have ever seen a ghost myself, particularly along the tour's route. It is generally only for these groups that I will tell of this astonishing experience.

In March of 2006, I saw my first, no doubt about it, full-bodied apparition. It was at the intersection of Sloan and Atlanta Streets, which happens to be where the very first Roswell traffic signal was installed in 1949. (Our city now has ninety-three traffic signals.) I have worked alongside seasoned paranormal investigators who have been doing their thing for decades upon decades and still have not seen their own full-bodied apparition. It is indeed a very rare occurrence, and there are a vast number of reasons for this. First of all, most agree that it takes a lot of energy for a ghost or spirit to manifest itself in this way. Another reason given is that not all people, much less investigators, are "clairvoyants" who have the capability of seeing full-bodied apparitions, or FBAs. FBAs are considered to be the holy grail, the much sought after experience by those wanting to prove to others or even to themselves that ghosts do indeed exist.

So there we were on St. Patrick's Day in 2006, and I was leading my tour group from the more affluent side of Historic Roswell over to the more humble side. As is usually the case, I picked up speed to get ahead of the group as we rounded a corner of Roswell's town square so that I could push the button at the traffic light. This particular night, something caught my eye across the intersection. Diagonally across the

The Intersection's Apparition

The intersection of Atlanta Street and Sloan Street where I saw the apparition.

corner I was approaching, I saw a man running. I looked directly at him and saw that he was sprinting toward the intersection. I felt a moment of panic as I heard cars coming from both directions on the main street. My eyes darted to the traffic light across from me where I verified that we did not have the right-of-way. When my eyes darted back to him I saw that he was in the middle of the intersection at this point. It was also at this precise moment that I realized this was no man at all. He was about 75 percent transparent! But I could make out an amazing amount of detail. I saw that he was short and wore black pants and black shoes, a white button-down shirt and a long, black coat. I noted that it was not a modern-style coat that we would see today. He was also quite pale, seemed to be in his mid-thirties and was balding, but the little bit of hair he had was light, possibly blond. I will never forget that his eyes were right on me the entire time. After I took the second to take all of those details in, and as a large truck coming from my left (his right) was about to cream him, he vanished right in front of my eyes.

Many people ask if others saw him as well. I'd have to say probably not, because no cars were swerving to avoid hitting him. The tour group approached from behind me, and no one said anything about it. Surprisingly to most, I did not say anything about this experience to the group I had there that night. I was very aware of the fact that if I myself

were on a ghost tour and the ghost tour guide remarked that she had just seen a ghost, I most likely would have thought to myself, "Yeah, nice try." Also, others who have experienced a full-bodied apparition have noted that they too needed a bit of time to simply process what they had just seen. Seemingly, there is an inability to put the experience into words right away.

Admittedly, if I were to hear this story from someone else, I'd have to say I would find it quite unbelievable, particularly due to the fact tha ᴏ one else saw this supposed FBA. But the difference is that I saw this exact man, this same full-bodied apparition, again a little later on that same night—in a different location along the tour's route—and I was validated by a woman in the group who saw the ghost as well this time.

7.

Jack's Old Cottage

Jack Richards, the creator of the original ghost tour in Roswell, lived in one of the oldest cottages in the mill village for nearly two years. These cottage homes were built for the millworkers in the early 1840s and were quite small and modest. Despite their size, the homes were known to have housed more than one family at a time with inhabitants filling in every space, including the attic spaces. In general, the entire mill village housed poor millworkers and slaves. Currently, as this is now Historic Roswell Mill Village, it's a highly coveted, quite expensive area to live and work in.

Jack was living here when I was hired as the new main guide. When I found out he lived along the tour's route, in this very old and historic home, I excitedly asked him if he had had any paranormal experiences in his home. I was disappointed to hear that he had not.

A couple of weeks after that conversation, Jack filled in for me and took a tour group out. He called me later that night very excited because it appeared that he had finally experienced some ghostly goings-on at his cottage that evening.

He had a very small tour group because the weather had been quite bad all throughout the day, causing several cancellations. He wound up with a set of parents and their son, who was about ten years old, and another set of parents with their son, who happened to be about ten as well. These families did not know one another, never having met before sharing this night's tour together. Just as they got to where Jack's cottage was, which happened to be about forty-five minutes into the tour, there was a sudden

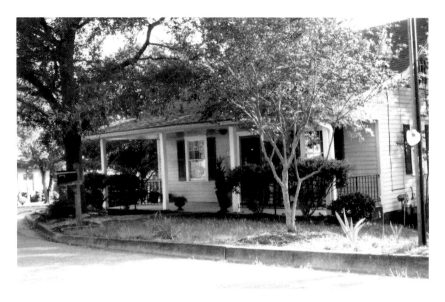

Jack Richards's old cottage.

downpour of heavy rain. Jack felt pretty certain that it would pass quickly, as it had done all day long, so he invited the two families to wait it out under the front porch of his cottage. Sure enough, about five or six minutes passed and the rain indeed stopped just as Jack predicted. They continued on and were able to finish the tour with no more weather issues.

At the end of the tour, Jack walked home from the town square where the tour begins and ends. As he walked into his cottage, his phone was ringing. He answered and found that it was one of the mothers calling from her cell phone as they were in their car headed home. As the family began driving away from Roswell, their son shared with them that he had seen two ghosts. His parents were highly skeptical, but wanted to hear what he had to say. He stated that as the six tour attendees waited with Jack under his porch, he saw a black man and woman at the end of the home's driveway. He noticed that they were short and barefoot and that the woman had a red bandana on her head; the man was dressed in overalls.

Children do legitimately, beyond active imaginations, experience more paranormal activity than adults do. They are still very innocent in their thinking and haven't had as many strange looks given to them when telling their tales; they have yet to close off their minds to certain aspects of things that others may not understand or accept. Additionally, there have

been studies that suggest there is a physical reason why children may be able to see more than adults do. The rods and cones in the backs of their eyes are not mature yet, not fully developed until around the age of eight, allowing them a broader range of sight, particularly in their peripheral vision. This diminishes somewhat as the cones and rods mature.

As tour guides, we hear a lot from children on the tour and we tend to keep them in the backs of our minds; usually their experiences do not ever come up again. This particular boy's story was different though. Most times we hear that children see shadows, which quickly disappear. This boy was giving a great amount of detail in his descriptions of these apparitions. He also stated that both the man and the woman looked him directly in the eyes, and then vanished.

Jack thanked this mother for calling and said it was an interesting story and he was glad they had shared it with him. Twenty minutes passed and Jack's phone rang again. This time it was the other boy's mother. They had just reached their home, and she was pushed into calling Jack, in fact, under duress. She hesitantly began to tell Jack that her son bugged her their entire way home in the car. He claimed to have seen two ghosts in front of Jack's house, at the end of the driveway, while they were waiting for the rain to stop. She and her husband were highly skeptical of this and tried to convince their son he had been imagining things. She eventually acquiesced to her sons pleading and called Jack, fully expecting this would end her son's insistence that he had actually seen ghosts that night. She begrudgingly related her son's descriptions of the ghosts he had seen.

Jack told her of the other mother having called as well, stating her son had seen two ghosts that matched the other boy's descriptions to a tee. He could tell from her reaction that she was genuinely taken aback, quite astonished. Her entire demeanor changed as she seemed to be unable to catch her breath for a full minute. He heard her tell her son about the other boy seeing the ghosts as well, and she asked if he realized that the other boy saw them too, to which he replied he had not. He was equally astonished that someone else had seen what he had indeed seen with his own eyes.

Looking back on that particular tour with the two families, Jack couldn't help but recall how the two young boys were mostly off doing their own thing for the first half of the tour. They were not paying him much attention at all. But Jack recalls that following the short stop at his cottage, the boys were right next to him the rest of the night, asking him all sorts of questions, particularly about slaves.

8.

Barrington Hall

Barrington King, son of Roswell King, had a beautiful Greek Revival home built in Roswell, which became known as Barrington Hall. It was completed in 1842, following five years of construction, and made of virgin pine, cut and seasoned for two years. For the home's wide-planked floors, termite-resistant heart pine was used. It has a three-sided piazza with fourteen Greek Doric columns surrounding the front and sides of the house.

Barrington King and his wife, Katharine Margaret, were the parents of twelve children. By the year 2004, their descendants had grown to over 1,350 people. Both Roswell and Barrington (amongst many others) died in this very home. Roswell King died here in 1844 at the age of seventy-eight. An interesting story recounts that the body of Roswell King, upon his death, was being kept in an upstairs bedroom in the home. A family slave was secured to sit vigil by Roswell's body until the time came for his wake. In the dark night, the room barely lit by candles, there was a sort of bellow that came from Roswell's body that sent this terrified man into such a fright that he either fell or jumped out of the upstairs bedroom window, resulting in his death from a broken neck.

Barrington died in 1866 at the age of sixty-eight after suffering from internal injuries due to a vicious kick from a horse. Eight of his sons served in the Confederacy. Two of them were killed and three of them were wounded. Of the three daughters he had, only one lived to adulthood. This daughter, Eva, married Reverend William E. Baker in

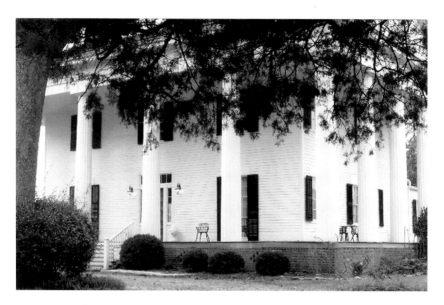

Barrington Hall.

Barrington Hall's parlor in 1856. The Bakers moved to Virginia soon afterward but returned to Barrington Hall in 1883 to help care for the widowed Mrs. Barrington King. When Mrs. Barrington King passed away in 1887, the Bakers purchased the home.

The Bakers had seven children and a great number of grandchildren who came to visit quite often. "Grandma" Eva Baker continued to live in Barrington Hall until her death in 1923. The home then passed to two of her granddaughters, Evelyn and Katharine Simpson. Miss Evelyn and Miss Katharine were never married, and they dedicated their lives to preserving Barrington Hall and all that was inside. Miss Evelyn passed away in 1960, and Miss Katharine lived at Barrington Hall until she died in 1995.

Then the home became the property of Miss Lois Simpson who had been a close friend of Miss Katharine and was legally adopted by her in 1977. When Miss Lois died in 2003, the house passed to Sarah Winner. Sarah restored the house with every intention of moving in and making it her own residence. It was in terrible disrepair at that time, so Sarah went about renovating the five-thousand-square-foot home, which originally had ten rooms, including five bedrooms, each with private dressing rooms. The renovations took two years and totaled close to $2

million. Thankfully, the house having stood for 162 years had no termite damage. Sarah went on to win the 2003 Excellence in Restoration Award, presented by the Georgia Trust for Historic Preservation. She made the decision to sell it to the City of Roswell to be shared with the community in 2004. In 2005, Barrington Hall was purchased by the City of Roswell for a reported $2.4 million. A veritable living archive with its mid-1800s furnishings, it is now open to the public and its interior and the grounds may be visited by all. According to the terms of the contract, the property will permanently be used for cultural, historical and educational purposes, and the undeveloped back sections of the property will be protected against future sale and/or inappropriate development.

There is a running argument in the city of Roswell as to what is the highest point in the city. It is either the grounds of Barrington Hall, which sits nicely atop a hill and overlooks the town—namely where the textile mills of the Roswell Manufacturing Company were—or Founders Cemetery, where many of the city's founding families are buried. Barrington Hall is now listed on the National Register of Historic Places and is referred to as one of metro-Atlanta's "50 Most Beautiful Homes" by *Atlanta* magazine. The home sits on seven acres of land with a carriage house, smokehouse and beautiful gardens.

A few years before Lois's death, an elderly woman named Lucille and her husband came to visit Roswell. Lucille was a King family descendent but had never lived in Roswell herself. She had been told of Roswell's charms and of the beauty of Barrington Hall, so she made a point to see the city of Roswell herself and was proud to introduce her longtime husband to the city that enchanted so many of her ancestors.

At the time of their visit, Barrington Hall still had a tall, sturdy fence surrounding the property. Lucille and her husband were desperate to get a good look at the home, particularly since they only had the weekend before they returned home, possibly never to get the chance to see Roswell again. Her husband found a way through a part of the gate, but Lucille said she was too much of a Southern lady and could never muster up the bad manners to trespass the way her husband dared to. She did follow him along the fencing as she watched him approach the large home with his camera in hand. She watched as he snapped off many photos, concentrating on aiming up toward the top of the home at one point. It was in this instant that Lucille noticed some movement in the side garden. She shrieked, causing her husband to lower his camera, and it was then that he too saw what Lucille saw. He noticed a woman in the side garden who had

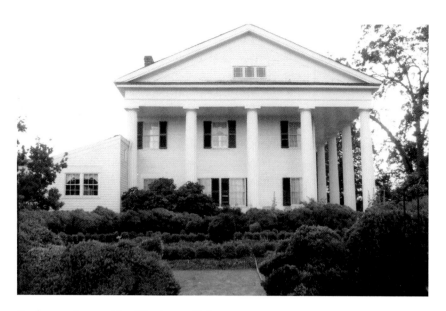

Gardens on the east side of Barrington Hall.

on a grey dress and a large white bonnet atop her head. Knowing full well that he was trespassing, he hurriedly shuffled back toward the hole in the fencing and felt he was able to leave the grounds undetected.

Lucille and her husband then proceeded over to Bulloch Hall where they took the tour of the grounds and inside the home. At some point, Lucille mentioned that her own grandmother had once lived in Roswell and knew Lois Simpson's relatives. The docent giving them the tour noted that Lois would be ever so angry with her if she found out that these lovely people were in town and were not introduced to her. The docent called up Lois at Barrington Hall, and Lois invited Lucille and her husband over for tea.

They were thrilled at the prospect of meeting Lois and of being able to see more of Barrington Hall and its property, this time while not trespassing of course. They drove in through the open gate, approached the home and were greeted by Lois herself. They had expected the woman they saw in the side garden to be Lois, so they were surprised to see Lois was not that woman at all, and was indeed dressed in modern clothing. Somewhere during their conversation with Lois, Lucille's husband couldn't help but mention that they had walked around the property earlier in the day and had seen a woman in period clothing, doing some gardening in the side garden. Lois looked perplexed and assured them that no such person was there that day.

Robert Winebarger, the gracious site coordinator of Barrington Hall since it became open to the public, has allowed me to arrange for several paranormal investigations there in the home. Bren Allison-Pettengill, present with us on one such night as she and her husband Hawk filmed the investigation for her documentary, recalls:

Barrington Hall is a beautiful antebellum home that has been preserved as a historical landmark in Roswell, Georgia. I wasn't surprised at all when I learned that there's reported paranormal activity in the home. I was invited by Dianna and the Georgia Ghost Society to film an investigation as a piece for my paranormal documentary. Excited by the idea that we'd have after-hours access to the property, my husband Hawk and I packed up our equipment and prepared for a night of investigation.

I was asked to film a smaller group investigating the cellar. I followed Dianna Avena, Alan of Iamhaunted.com, and Bob Hunnicutt, the team's lead investigator, outside to the cellar access door. We were advised that people often felt "creepy" feelings in the cellar and our chances of experiencing something paranormal were more likely in this location. We took position in the second of three sections so just a mere twist of the neck in either direction gave us full view of the entire basement. The cellar was dark, cold, dank, and still. The slightest movement upstairs gave life to the smallest shadow below. A few short moments into the investigation, Alan became ill and exited quickly. As I followed to check on him, I passed through a doorless doorway and stopped dead as the sensation of a warm hand applied to my back gave me momentary paralysis. The fine hairs on the back of my neck stood on end and I quickly reported to the two remaining investigators, "I'm being touched right now. On my back, I'm being touched right now."

Dianna and Bob flew to my side and in moments we were all enveloped in chills. Dianna reached out with both arms as I declared that the sensation had subsided, only to report a feeling of being touched as well. Dianna's experience was much more intense, as she stated the hand on my back had grown arms, which were now hugging her from behind. In the next few moments, the sensation subsided then recurred, weaker than before, then dissipated altogether. Alan returned to the cellar soon thereafter and we remained in the spot where both female investigators were touched, trying to goad the spirit into allowing either Bob or Alan to experience the sensation as well. Though they confirmed our reports of chills and a drop in temperature, Dianna and I were the only two to experience the phenomena first hand.

Bob Hunnicutt, director of the Georgia Ghost Society, writes:

> *Roswell is no doubt an interesting and definitely haunted Georgia city with locations like the Barrington Plantation! This beautiful and unique 1842 mansion is one of the most fascinating locations I've had the privilege to investigate. While centering our investigation on the downstairs bedroom, several of those present heard auditory phenomena and during one of our E.V.P. (Electronic Voice Phenomena) sessions, my right hand was grabbed and squeezed as if someone was attempting to hold my hand. This is one location that I would love to have the opportunity to investigate again in the very near future.*

We at the Roswell Ghost Tour are also aware of paranormal activity occurring in homes that are built behind Barrington Hall. These current homes are built on what was Barrington Hall's original property in the mid-1800s. We have been called by three different homeowners, all stating they have seen an apparition of a tall black man in overalls walking throughout their homes. One of those homeowners, Betty, had recently dug up a hand-made hoe in her side garden that she believes is over one hundred years old. After stating this to Barrington Hall's site coordinator, Robert, he remarked that that spot is the area where the original home's vegetable garden was, so it would make sense that a gardening tool would have been found there.

Jack Richards also once lived in a home directly behind Barrington Hall. He recalls:

> *This home was built over where Barrington Hall's hogs and chickens were kept. Our house was a newly designed house and it was built over what was most likely a cemetery for a church that was located here during the Depression era. The land was filled in and our homes and local businesses were built over that area.*
>
> *My business partner and I lived and worked out of this home for a year and a half. I had lived in Savannah for many years where I began the Savannah Ghost Talk Ghost Walk. I can tell you I have never experienced a location with as much activity as we had in this home in just that year and a half period of time.*
>
> *My business partner routinely heard music coming out of the woods at night when the windows were open. On nice days, we'd leave a door open at the front of the house, while just leaving the screen door closed.*

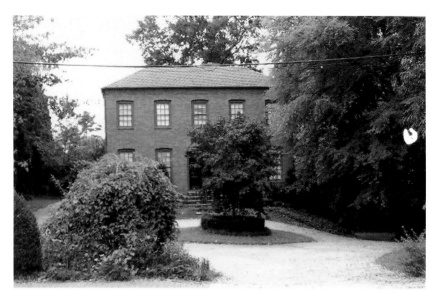

Home behind Barrington Hall where Jack Richards used to live.

Oftentimes we'd hear a client walking up to the front door by their walking on the pea gravel. There were many times when we would hear that crunching, get up to greet the guest, only to find no one physically there. A friend of ours, Marika Thomas, came to visit us and she heard the crunching of the pea gravel behind her as she approached the backside of the house one day. Of course, she turned to see who was behind her and saw no one.

We had a pet cat living at the house with us, but we also saw a second cat—a ghost cat. In fact, many different people saw that cat. Also, there were two occasions where there was a loud rapping at the front door when other guests were in the house, but no one was at the front door. That front stoop is very open, so there were no trees or bushes for someone to have run into to hide in. On other occasions, the front blinds began to knock around by themselves.

One night an overnight guest awoke in the middle of the night and saw a woman was standing by the side of his bed only to then suddenly disappear.

There were two occasions where an employee by the name of Michelle had her purse flung across the room by itself. In that same room, from the desk, an architectural design triangle flew across the room as well.

We had an antique clock that had been purchased at an antique store on the coast, but it would ring by itself, unsolicited, even though the weights were off of it and it shouldn't have been able to work. One night at a dinner party when we had a total of eight of us there, we were all talking somewhat badly about someone we knew in common. Suddenly, the clock flew off of the wall and broke into many pieces.

In general, some of the staff members who work at Barrington Hall state that there have been sounds of footsteps and voices with no source for the noise. Smells of cigarette or cigar smoke will suddenly begin to waft in the interior or outside on the grounds and no apparent source can be found. We suspect that as time goes on and more time goes by where the staff is alone in the home, we may be privy to many more unexplainable goings-on in this very historic home.

9.

Founders Cemetery

Many of Roswell's founding fathers are buried at Founders Cemetery. The first body buried here was in 1841 and the last body was buried in 1860. A few of those at rest here include Roswell King, James Bulloch and John Dunwody. The first body buried here was actually that of a child in the Bulloch family who died of scarlet fever at the age of two. His name was Charles Irvine Bulloch, the son of Major and Mrs. James Stephens Bulloch. He was the first of the area's children to succumb to the outbreak of scarlet fever at that time. Roswell King himself was buried in Founders Cemetery in 1844. Upon his engraved headstone reads:

> *In memory of Roswell King, born in Windsor, Conn. 3d May, 1765, and died at Roswell, Cobb Co., Ga., 13th Feb 1844, aged 78 years, 9 months and 12 days. He was the founder of the village which bears his name. A man of great energy, industry, and perseverance, of rigid integrity, truth and justice, he early earned and long enjoyed the esteem and confidence of his fellow men. His children have erected this stone to his memory.*

There are magnificent tombstones, some obelisks, for many of the founders' graves. One cannot overlook that there are also over sixty stones jutting up out of the ground in parallel rows throughout the cemetery, even between those of the wealthier, founding families of Roswell. There is quite an interesting story about how these particular stones, marking unnamed bodies, came to be.

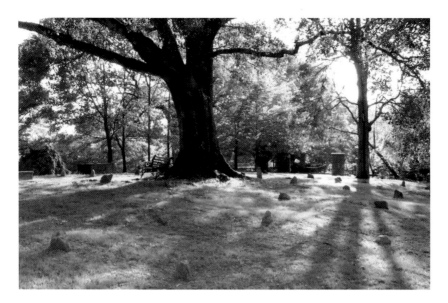

Founders Cemetery.

FOUNDERS CEMETERY
1840–1860

The original burial ground once associated with the Roswell
Presbyterian Church contains 28 marked graves of some first
families of Roswell and their slaves. The first burial was that
of Charles Irvine Bulloch, aged 2 years, who died of scarlet fever
during an outbreak in Roswell in the summer of 1841. Town founder
Roswell King died February 15, 1844 and lies beneath a monument
erected to his memory by his children. Flagstones identify 65 graves
discovered in 1984 during a geophysical survey of the cemetery.

Roswell Historical Society

Historical marker at the Founders Cemetery.

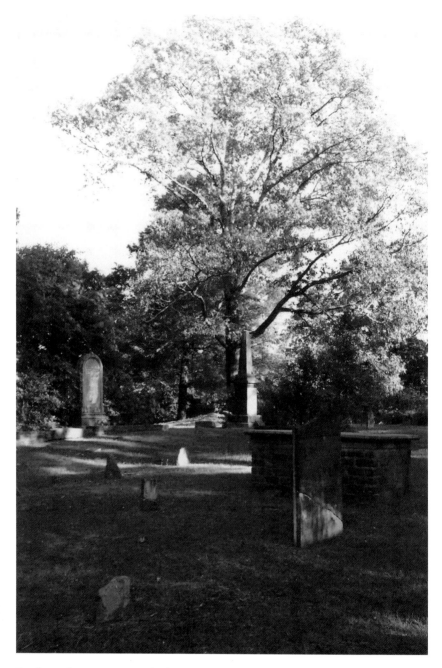

Small, nondescript stones mark where slaves were buried along with the city's founding families.

In the late 1970s, a local newspaper published an article about how much of the land around Founders Cemetery was sold to homebuilders in the area. After doing a little of my own digging, it turns out that this is very well documented. I personally spoke to some of the builders and realtors that were originally involved in those very dealings, and there is no doubt that many, if not most, of the homes that are near Founders Cemetery are indeed built over land where bodies were buried during the years between 1840 and 1860. There is a stack of large stones off to the side of the current cemetery where city workers stacked the stones as they found them, while working at building the street and small parking lot for the cemetery. It is thought to be a very conservative figure to estimate that what we see as Founders Cemetery today is most likely only one-third of the land where bodies were originally buried during that two-decade time span in the mid-1800s.

A private organization, upon reading that published article, took great interest in the subject. They took it upon themselves to bring out heavy ultrasound equipment and find where the bodies from the unmarked gravesites were buried. They stayed only within the confines of what we see as the cemetery today and found sixty-six unmarked graves. They were the individuals who placed the simple stones at those plots, otherwise we may still not know of their existence today.

It is believed that these graves of unknown persons were those of the families' slaves. Those who work in the business of cemeteries and burials would argue that that is impossible. The mixing of the classes, particularly during that period, was unheard of. Roswell, Georgia, was quite unique though in that regard. It is quite probable that those unmarked graves were the families' servants. Too poor to afford tombstones for themselves, yet they were buried alongside the wealthier families nonetheless.

What the current residents living in the homes around the cemetery may be experiencing has always been a topic of interest for me. It has been a staunch rule of Roswell Ghost Tour not to go knocking on doors to ask for stories; rather, they have always been voluntarily offered to us. We do hear of many families reporting unexplainable lighting issues where lights go on and off by themselves, and light bulbs tend to burn out well before their time. Odd sounds can be heard over the roar of the nearby waterfall, which flows over the dam at Vickery Creek.

At one private residence, a teenage boy has often reported that a very bright light has suddenly shone into his room through the window,

The waterfall at Vickery Creek.

waking him up at night. That window looks out over Founders Cemetery. Each of the times this unexplainable light has overtaken his room, he's assumed the only source that can generate such a big light is a helicopter's searchlight. He never hears the sound of a helicopter at these times, but he rushes outside to try to locate such a source, yet to find one.

Another nearby family has stated that they hear people's voices and possibly sounds of people gardening around their home. This happens at all hours, day and night. When they first moved in, they would go outside to see who was on their property but never found anyone. After many months of attempting to find the persons responsible for the voices and sounds they heard, the family has since given up and accepted that they're most likely residents of Roswell who no longer walk the earth alongside them.

Another woman resides in a home across the street from the cemetery, but far enough away from it to where her family cannot see the cemetery from their property. In the late 1990s, this family decided to have their driveway widened. While the workers were there taking down the existing wooden retaining wall, in doing so, they found they had inadvertently taken down the side of a wooden casket that was inside that wall! Easily taken care of, the casket was moved to a more proper place, the driveway was widened and a newer stone wall took up its place. Today it is noted

that if a car is to stop at that spot in the driveway with the engine running, the engine and the electrical system will both stop, but if the car is taken elsewhere, all will be working just fine again. Anything requiring batteries such as flashlights or even cellphones will also die, or "drain" if being used at that spot in the driveway. Is the energy of the person that was buried there interacting with these things to make them malfunction in this way? Or are there yet other bodies buried amongst these homes and driveways that are trying to get our attention as well?

At a neighboring home, this one a little closer to the cemetery and in full sight of it, there are strange occurrences in the driveway as well. The lady of the house had her brakes go out on her as she was descending the steep driveway, causing her to plow through a brick retaining wall. Another time, a friend was arriving for a visit with her teenage daughter in a wheelchair. The mother had hold of the wheelchair but lost her grip, which sent the chair—with her daughter in it—down the driveway where she tumbled at the base. Another night, this woman saw through her kitchen window that there were several policemen at her neighbor's house. She went out to see what the problem was and found out that her male neighbor had apparently tumbled down his own steep driveway and fallen to his death. This homeowner decided to have her driveway blessed soon after that and has placed several angel statues around the driveway since then. Fortunately, there have been no other dangerous issues at her property since she had the blessing performed.

In another instance, a previous homeowner behind the cemetery grew tired of his very small backyard, so he decided to do some work back there to widen the living space in the mid-1990s. He rented some equipment and began removing much of the earth that served as "walls" on the backside of his property. He came across many rocks and such that made this task quite difficult, but he came across something quite large that he eventually wound up breaking through. He was astonished to see that it was a casket. This happened roughly thirty or forty yards from the closest gravesite he could see over in Founders Cemetery, so he was not expecting to find something like this at all. After sharing this experience with others over the years, he has noted that everyone seems to ask the same first question. "Did you look inside of it?" He states that he did indeed look inside of it and found the skeleton of what he feels was a man due to the clothing he was wearing. He says that it looked to be clothing that was worn in the mid-1800s and that he couldn't help but notice that there was never a head to be found inside this casket.

This gentleman was living in this home at the time that the press was all over the stories surrounding the cemetery in the early 1980s. He did not want to stir up any more problems or issues with any of that mess again, so he made a decision. He decided he would go ahead and live with his smaller backyard after all. He put the dirt back the way it was, casket still behind it, and he now has an interesting story to tell for the rest of his life.

One of our Roswell Ghost Tour guides, Tim Senay, has long been intrigued by the question of what the actual highest point in Roswell is. While he was in training, he was required to attend three separate tours himself. Raised in Roswell and a communications officer for the 911 Center, he was able to acquire the use of a sort of GPS system that measures elevations from the police department. He brought this device with him for each of those three tours in hopes of finding out the answer once and for all. He measured Barrington Hall's property to be somewhere around 1,100 feet. Each of the three times he placed that instrument at Founders Cemetery, it vacillated wildly between 850 to 1,300 feet. So, unfortunately, we were unable to determine the highest point due to the equipment malfunction.

Paranormal investigators consider "battery drain" to be a reasonable sign of paranormal activity. One theory is that if a ghost or spirit wants to show itself or manifest an action of any kind, it needs to draw upon the energy around it. (This can also be the cause of "cold spots," which are sudden drops in temperature at a haunted or active location.) Because much of the equipment that we use relies on battery power, experienced paranormal investigators know to replace the batteries in all of their instrumentation and cameras before going on a study.

Founders Cemetery is very routinely an area for battery drain and for malfunctions of all sorts of instrumentation. We have been followed by camera crews for news stories, for official documentaries and of course by hundreds and hundreds of our everyday tour attendees. The numbers of them having unexplainable malfunctions of their cameras is astonishing. We have witnessed video cameras, news cameras and film and digital cameras completely shut down, only to begin working fine at the next stop. One night, as a news crew followed one of my tours with two film cameras, each of the camera's batteries completely died while we were standing in the middle of the cemetery. The cameramen were astonished that their cameras gave them no forewarning. They certainly should have been able to last another hour or two based on how long they'd been in use up to that point.

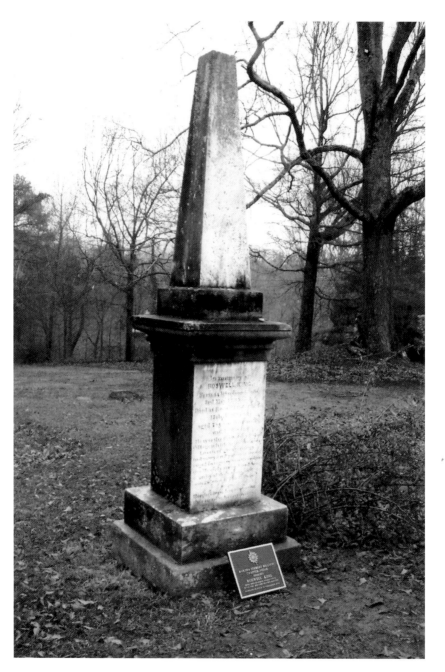

Monument at Roswell King's gravesite in Founders Cemetery.

Tree in Founders Cemetery where several tour-goers have seen a child watching us.

In another incident, one of our Roswell Ghost Tour guides needed to supply us a photo of himself to put on our website. While he was in training, so therefore tagging along on a few of the tours, he brought along his camera in hopes of getting me to snap a photo of him next to Roswell King's tombstone. Sounding like a great idea, we did attempt to get this shot of him on several different nights. However, each time there were issues that kept us from ever getting that photo. Either the camera did take the shot but it came out to be a fuzzy, white blur, or the camera wouldn't take the photo at all.

Serena, a tour attendee, related a similar experience:

> *When we were at the cemetery, my camera did not work properly. But as soon as I left the area, it worked again. Someone else on the tour had problems with her flashlight around the same time. We went back the next day to see if it would happen again and it did. The battery drained. Each time, I was next to the grave of the 2 year old boy.*

For those that are impressed with orb photos, Founders Cemetery delivers almost every time. Generally, we feel most orb photos are the result of dust or moisture particles in the air. Often though, we do see photos taken from tour attendees that are impressive. Big, bright, seemingly in

motion orbs are caught on camera. Also, bright white or blue balls of light have been seen with the naked eye. Here is one interesting account from a repeat tour attendee, Rhetta Akamatsu:

The first time my husband and I took the Roswell tour, I was very excited to enter Founders Cemetery and realized that I had been there once before. I was lost at the time, and a friend and I stumbled on it by accident. I had been amazed to discover the grave of Roswell King, because I had read about him in Eugenia Price's books. When the tour arrived at the cemetery, I walked over to Mr. King's stone, and playfully put out my hand and said, "Hi, Mr. King, do you remember me?"

My husband snapped hundreds of pictures all during the tour, and he took a picture just at that moment. To our surprise, when we looked at it, it was covered in very large orbs. I am not much of a fan of orbs, but these were especially large and appeared patterned. There were no orbs in any other pictures in the graveyard.

On our second time on the tour a few months later, we tried taking pictures again at the grave, and no orbs showed up. My personal feeling is that Mr. King was answering my question, although I'm not sure what he was trying to say.

There are parts of the cemetery that seem to cause groups of people to want to hurriedly vacate the premises. There is also a large tree where several tour attendees on different nights have reported seeing what looked like a child peeking around that tree at us.

10.

Katherine's Cottage—Fire in the Walls

This is one of the oldest cottages in the Historic Mill Village. Originally built for millworkers' families in the early 1840s, it was a duplex like most of the homes were at that time, having a fireplace in the middle of the building. Although it was quite small, it usually housed an alarmingly large number of people. Its paranormal activity is quite interesting and many recall this location as having one of the tour's most memorable stories. And it's a story that developed over many months.

The building had apparently been abandoned for many years, requiring much renovation. A woman by the name of Vickie purchased the old cottage in hopes of opening up her new business there. Heavy renovations began, which included new hardwood flooring, electrical wiring and sheetrock. One morning, the workers approached the home to start another work day when they saw that a pipe to which they were preparing to install a sink was shooting out water and had apparently been doing so for hours and hours. This unfortunate incident ruined all that had been done to the cottage at that point. Unwavering, Vickie began the renovations again, and again reached the point at which the hardwood floors were in and the wiring and the sheetrock were repaired

Once again, the workers approached the cottage to begin work one morning, and again they saw tremendous water damage. This time the culprit was a new hot water heater. It had been installed days earlier, and they saw that it was literally split in half. They could not understand how a brand new hot water heater could have split in half that way; it was unheard of.

Katherine's cottage.

Ever persistent, Vickie had the workers begin yet again, and this third time she was pleased when she noticed they were near completion. All was renovated; she had new furniture, desks, phones, an emergency sprinkler system installed in the ceilings and computers in every room. Vickie opened the office door just days before they were officially done with everything only to find that the emergency sprinkler system was shooting out water onto everything. For no apparent reason, the emergency sprinkler system continued to spray out water for hours and hours.

Vickie was very distraught as the water damage was so severe that it resulted in over a quarter of a million dollars in insurance claims. She had met her neighbor Jack Richards by this time and knew of his interest and knowledge of all things paranormal. She proclaimed that she felt there was an angry ghost in this building and that they needed to have something done. He happened to have a psychic/medium friend named Lucy coming through town a few days later so he asked her to visit the old cottage.

Knowing little of what Vickie had been through with the strange water damage incidents, Lucy went about her business of seeing who at this property wanted to communicate with her. She stated that she was able to communicate with five separate female spirits. Each had the same story, that they were there waiting for their husbands to come back from the war.

According to Lucy, four of the female spirits moved on, but one remained. This spirit stated that her name was Katherine and that this was her home. She also told Lucy that she was very upset at these newcomers in her home (Vickie and the workers renovating the house). Katherine was upset about the addition the workers had added to the back of the home. She stated that she used to look out a window above the kitchen sink on the backside of her duplex. She enjoyed looking at down the hill to the creek where she used to watch her husband walk up at the end of each day after working at the mill. She was very angry that these newcomers had made it impossible for her to see this happen again.

Also, Katherine stated that she was most frightened by the constant "fire in the walls." This was a definite mystery to poor Lucy who was trying so hard to help out both Vickie and Katherine. Finally, it occurred to Lucy what Katherine had meant. Katherine had no idea of the concept of electricity and perceived the electrical wiring in the walls as "fire in the walls." She communicated that she was tired of feverishly having to put out the fires in the walls. So it was apparent to all involved at that time that Katherine was the one responsible for all the water damage.

Lucy tried yet again to convince Katherine that it was time for her to move on, but she still refused. Vickie wanted to do whatever it took to get Katherine taken away from this cottage where she had spent a great deal of blood, sweat, tears and money in trying to restore it. Jack felt a simple act could help her situation, one that would allow both of them to happily remain at the cottage.

They gathered items they had found during the renovations, such as letters, nails and even a very old pair of women's shoes. They enclosed these items in a glass encasement and put Katherine's name inside to honor her presence there. When Vickie was finally able to successfully open for business, she had a great big party to celebrate. They all made a big deal about welcoming Katherine at the office and were pleased to note that they didn't have issues with water damage ever again.

The business has since moved elsewhere, and the building is now used as office space for a different business. However, the glass encasement with Katherine's name and items is still standing between the two front doors in what was the original duplex home. Apparently, the new business owners do not want to tempt fate with Katherine.

11.

Old Bricks

The latest flurry of paranormal activity that our tour-goers have been witness to involves the Old Bricks. These buildings are architecturally significant because they are the first townhome-type buildings to be built in the United States. They were built for the Roswell Mill's foremen and their families. During the Civil War, the Old Bricks were taken over by Union soldiers and used as a hospital for their wounded.

In the early 1990s, the Old Bricks were purchased by a family whose company put together a social club. It was called Founders Club and could be rented out for various events. These owners decorated the interior with Civil War–era antiques and had a very nice security system installed with motion sensors everywhere. One afternoon, a couple of large prints were brought in. They were placed on opposing mantles in a large room, the security system was set and the building was locked up for the evening. When the owners came in the next morning, they saw that the print depicting the Union soldier was faceup on the floor quite a bit away from the mantle it had been placed on. The security system was never tripped, and there was no damage to the frame whatsoever. However, the glass was shattered in a spider web effect, looking like someone with a large boot had stomped on it.

Apparently, odd happenings would occur to that particular print any time they tried to include it in the building's décor. The inhabitants felt this was an act of aggression by what had to be the ghost of a Confederate soldier who was not very happy to see a large photo of a Union soldier in his own dwelling. He became known as "Fred" by the employees and

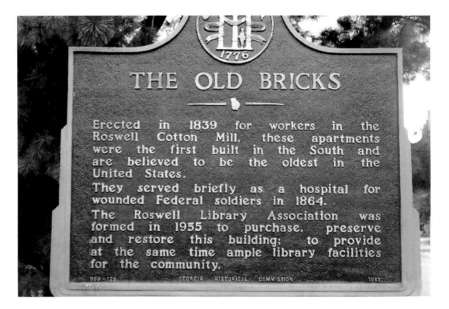

Historical marker at the Old Bricks.

The Old Bricks as they appear today.

members of the Founders Club, and they were witness to many other signs of his presence. There was no particular reason for this chosen name; they just felt the need to name him since they referred to him so often. Although that first occurrence was a bit aggressive, the majority of his actions were more prank related.

One such prank occurred while many of Roswell's finest were present at a cocktail party in the club one evening in the late 1990s. A gentleman who lived across the street from the Founders Club was in attendance and was standing with others in a circle while he drank his cocktail and told stories to the small group. Suddenly, he was physically lifted up off of the ground just high enough to be turned around 180 degrees before being placed down. Right in front of everyone's eyes, he was turned and placed with his back to his audience!

The club's main kitchen was downstairs and to one side of the building. Many of the kitchen workers over the years avoided leaving the kitchen area because they knew that the majority of the strange happenings, sounds and unexplainable drafts occurred upstairs and on the other side of the building. One night, the adult daughter of the owners who ran a lot of the events was upstairs with two workers as they prepared a room for a business luncheon that was going to occur there the next day. They readied seven tables with six chairs at each table, setting up the cloth napkins, plates, glasses and silverware. The workers were with her the entire time during the setup, and they walked downstairs together where they had a quick meeting and were then dismissed for the evening. The daughter ran back upstairs to turn off lights and gather her belongings when she saw that at one of those prepared tables, each of the chairs had been pulled back, the cloth napkins were draped over the backs of the six chairs and the silverware was crossed on the plates like Fred had had his own little dinner party. It turns out that this was a very common occurrence, as oftentimes the employees would ready a room that was rented out for an event the following day. It became routine that employees would make it a point to enter those rooms well ahead of their guests to assure that furniture and items were where they should be. Apparently, Fred made it a common practice to have dinner parties himself during the middle of the night.

Founders Club closed its doors for business in 2005, and the Old Bricks were gutted for new construction, which would be added on to the back in preparation for division into individual condominiums. I find it not very coincidental that our tour guides and tour-goers saw more activity around these buildings when they were being renovated. It seems Fred is

not too happy with all the commotion, which follows suit with common knowledge regarding this type of scenario. Many hauntings are reported to increase significantly during a time of renovation. Simply changing a room's furniture around or making changes in paint color or wallpaper may elicit an increase in a haunted place's activity.

Just as the gutting process began in the Old Bricks in the fall of 2005, I had a tour group standing in front of me while my back was facing the building. I was telling of the many pranks that Fred had pulled on the staff over the years when I began to feel an intense cold on my back that was undeniable. I chose not to mention this to the group as I often don't. I prefer to let the tour-goers tell the rest of us what they may be experiencing. Suddenly, several of the tour attendees shouted that the upstairs window behind me was opening. I turned around fully expecting to see an upper pane slowly lowering, which would have made sense with all the work being done as the construction could have caused the windows to loosen. But that wasn't the case. We all watched in astonishment as we saw the lower pane of the window rising upward! I noted that the original doors were still intact, but the thresholds had been ripped out at that point. We were all able to see through the four-inch gap between the bottom of the doors and the brick porch that the bottom floor had been removed; we could see directly down into the basement area. All there were in agreement, that if there wasn't a first floor, there probably wasn't a second floor. Even so, if a person had managed to get to that second floor area, we couldn't see how a window could be lifted without us seeing an arm or a stick that was used to do so. This is the one and only time that I wanted to quickly leave a location while in the middle of giving a tour.

I announced that I wanted to leave and proceeded to do just that. I recall that I walked away, walking backward so that I was able to keep my eye on the group, and I could still see over the brick wall to view that the window was continuing to open even wider. Suddenly, I realized I was hearing loud, clunky footsteps approaching me from behind. I realized someone from our tour group had apparently gotten ahead of me after all, so I proceeded to turn my head, planning to make a remark about the rest of our brave group still standing there, when I realized there was no one behind me after all. I then loudly announced that I was hearing footsteps and that I felt it was time to leave!

A few weeks later, much construction was still going on at the Old Bricks, and we began to hear many accounts from our tour-goers that the ghost of a young girl was in the building, as well as the ghost of a Confederate soldier. Near the end of November, a college-aged young man had his video camera

The most active unit.

on as he was preparing to do a student film on ghosts and hauntings for one of his classes. He was filming up toward the building while I talked when he suddenly yelped and jumped backward. I stopped and asked him if he was all right, and he stated that he saw a girl looking out at us from a downstairs window. We all ran toward that window because the building was a very dangerous place for anyone to be in at that time, especially a child. We pulled out our flashlights and looked through all the windows, not locating anyone inside. The student played back his tape several times, and we were all able to see what he had seen. No one saw anything in that window with our naked eyes from the sidewalk, but through his camera, we were able to see that he most definitely caught a young girl popping up into the window to look at us for a few seconds. After we heard his yelp, she vanished.

On following nights, other unexplainable events took place here. One night, I was physically pushed off of a step in front of the Old Bricks where I routinely stood while talking. I immediately looked behind me to find no one there. I would often feel the sensation of having my left thigh grabbed from behind, only to see nothing at all there. Other times tour attendees stated they felt a child was trying to grab their hands while they stood listening to me talk, only to look down and find no one visibly there at all. Another night, a high

school–aged girl sat in front of me on the sidewalk as I talked. She continually distracted me by swatting at her neck and head. I recall that I assumed there was a bug flying around her, but as we walked to the next stop, she whispered to me that she felt like someone was playing with her hair.

On a warmer than usual night in January of 2006, I hosted a group of exactly fifty-three eighth graders from Florida. They were up in our area on a Civil War educational trip and were ending their week with ie Roswell Ghost Tour. I could tell that the chaperones were really frazzled at this point after having to keep all of them corralled all week long. While we were gathering in front of this particular stop in front of the Old Bricks, I noticed that each of the doors was removed from the doorways in the front of the building. The chaperones all stood over to one side and quietly talked to one another while I attempted to keep all the kids quiet long enough to tell them about some of Fred's exploits.

I proceeded to discuss the building's history when all of the kids gasped at the same time, asking why there was a young girl in the building. They felt it was unsafe, and some wanted to know if they could go in the building as well. Others wondered where her parents were and why she was allowed to be in the building by herself. I was very cognizant of the fact that it didn't seem as though one or two of the children began talking of these things and that the others then reacted to what they said. They were all gasping and pointing at the exact same time. According to these children, as I was talking they saw a girl about the age of eight or nine walk into the door frame, look out at them, then continue in the direction she was going just inside the doorway. I was finally about to finish my stories about Fred, feeling none of them had heard a word I said about him, when all of a sudden each of them screamed at the tops of their lungs and ran bolting in the direction of our main intersection. My husband still gets frustrated at hearing this part of the story because he cannot believe I did not think to look behind me to see what they apparently saw. I believe that the mother in me took over the ghost hunter in me because they appeared to be out of their minds with fright, and I truly worried that they would run into that intersection and into oncoming traffic at the rate they were going.

Luckily, the chaperones and I caught up to the group of eighth graders just before they reached the intersection. Two of the girls were hyperventilating so badly that they needed to be tended to by the nurse in their coach bus who was traveling with them. The rest of the group proceeded to all yell at the same time, "She ran out at us!" According to them, the fifth time the girl in the Old Bricks approached the open doorframe, she turned to face our

group yet again, only this time, instead of turning back within the building the way she had been doing, she bolted out toward us on the sidewalk. This is what sent the large group running and shrieking.

With the very next tour group after this one, we began having our tour attendees sign liability waivers before proceeding to start the tour. If you ever have the chance to take the tour yourself, recall this story when you're signing your liability waivers because it was due to these fifty-three eighth graders nearly running into oncoming traffic in their panic that led to us feel this was necessary. We cannot be responsible for the reactions our tour attendees have to whatever they may witness!

Ed Laughlin, a paranormal investigator with Historic Ghost Watch and Investigation, had a paranormal experience here as well:

While on the Roswell Ghost Tour Dianna Avena was leading the group down a brick sidewalk passing in front of a row of buildings called "The Bricks." As we were walking a street light cast the tour group's shadow onto the street. I glanced to my left to look at the buildings across the street when I noticed a shadow on the street moving faster than the others. Thinking it was someone in the group wanting to pass me on my right I looked to my right as I moved to my left to let them pass. As I looked to my right and behind me I saw no one! The nearest person was at least six feet behind me and they were keeping the same pace as everyone else. I glanced back to the left just as the shadow disappeared into the darkness of the street where the street lights weren't casting light.

A repeat attendee of the tour, Ariadne Nikiforou, recalls:

While you were giving the history of the old town homes, and the story of the little girl often seen in the doorways, I felt someone "leaning" on my left shoulder. It was strong enough to knock me off balance. I turned to see who it was and there was no one there.

Then on the way home that same night, I called my husband to let him know I was on my way, and on the other line, all he could hear was a man's voice. He thought someone was carjacking me. I could hear him repeating my name, but he couldn't hear me answer, just a man's voice. I hung up and called him back, he was very frightened that I was in danger, and I told him there was nothing wrong, and everything was okay. When my husband told me about the man's voice being heard from my cell phone, my hair stood on end.

12.

Voila Hair Salon

One spring evening when I approached the bandstand where we assemble to begin the tour, the usually quiet town square was bustling with activity. There was to be a festival that weekend so many vendors were setting up in preparation for the next morning's events. Of course, I was wearing my "Roswell Ghost Tour" t-shirt as I always do and one of the vendors noticed it. He and a friend of his walked over to me and said that his salon was haunted. I asked which one, and he said, "Voila Salon, just down the street here on Sloan Street." The salon is along our tour's route; we pass it twice each and every time we do a tour.

The two men—longtime Roswell residents Thomas Tolbert and Voila Salon's owner, Scott Law—told us a bit about what they have experienced there. Most notable, the employees do not like to be in the building alone, particularly after dark. The upstairs area is an uncomfortable place for them to go at any time of the day or night. Unexplainable cold spots are routinely felt in particular areas of the salon as well. Scott is often teased by his employees due to the fact that his hair dryers blow up no matter where he plugs them in. It's only the blow-dryers he uses and it doesn't matter how old or new the dryers are.

The salon runs out of an old cottage in the Historic Mill District. This house was originally built in the early 1840s as one of the many duplex homes built for the millworkers. The wall that once divided the home in two is now gone, and it is astonishing to see how small the living spaces were in these homes for the millworkers and their families. Scott says that

Voila Salon operates out of an old millworkers' duplex built in the early 1840s.

many items have been found in the attic, and they feel it's apparent that people were using the attic itself as living space at one time. This old home was once considered the "duplex house of ill repute" as it was home to a madam and she ran her brothel out of it for some time in the early 1900s.

Almost any home found here would have been the site of numerous births and deaths taking place over many years. But legend has it that two women died in tragic ways at this particular home. According to the legend, a woman committed suicide in front of the hearth once she realized that the Union troops were seizing all the women and children remaining in Roswell because she felt her fate would not be a happy one if she went along with them. Also according to the legend, a second woman was murdered in this same home by Union soldiers.

There have been many sightings of a woman standing at the fireplace where the previously mentioned woman supposedly slit her throat. Also, there are sightings of a woman who wears a large ball gown and roams throughout the old home, particularly up and down the stairs.

Amy Wheeler, a stylist who has currently worked in the salon for a year, has already had her share of eerie happenings. On one particular occasion, all of the employees were in the salon on a Monday morning for a class. The salon is usually empty on Mondays as they are closed for business

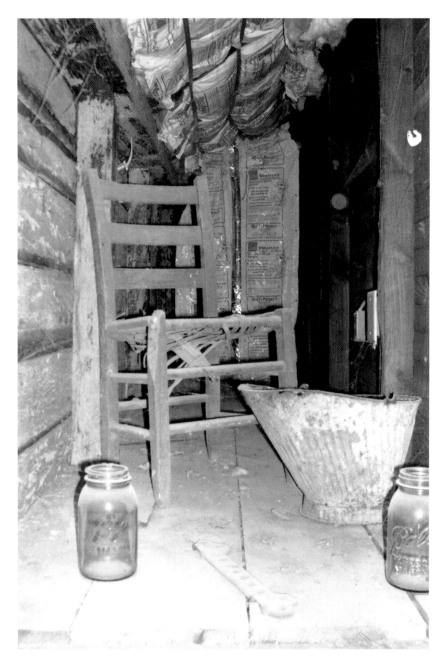

Items found (and left alone) in an attic crawl space in current day's Voila Salon. *Photo courtesy of Ryan Nubel.*

The hearth in what is now Voila Salon.

on that day. Everyone was downstairs, but all in attendance heard a loud thump that came from upstairs. A fellow employee, Manuela, went upstairs to investigate. She found that a lid on top of a trash can had apparently flown from where it was secured to the top of the trash can and had landed several feet away.

On another night, Amy was the last person in the salon as she finished with her last client around 8:30 p.m. The client had offered to stay with Amy to walk out with her, but Amy stressed she just needed to quickly sweep up her area and turn off lights, and she would be right behind her. Alone in the salon, she had swept the hair into a small pile, rested the broom very securely in the corner against a door with deep molding and stepped around a corner to grab a dustpan. She heard a loud noise and when she returned to her station, she found that the broom had fallen, but in no way could it have fallen on its own and landed the way it had, which was quite a bit away from where she had left it. Plus, the angle at which it landed was impossible due to the way she had secured it. She left all as it was and immediately fled the shop.

Scott allowed us to conduct a paranormal investigation of this property, and I invited one of the teams I am a member of, the Georgia Ghost Society, to take part in this one. We were also extremely lucky to have John Zaffis, world-renowned demonologist, with us. He is referred to as the "Godfather of the Paranormal," having had around thirty-five years of experience with hauntings, demonic possessions and paranormal investigations. We found it interesting that we were allowed to conduct our investigation completely alone. None of the salon's employees had any interest in being there at night, and we realized then how serious they were about that.

Drew Hester, co-director of the Georgia Ghost Society, recalls our investigation there that night:

> *While running the baseline upstairs I had the Tri-Field Meter. Throughout the rest of the house turned salon, the baseline showed normal readings, but suddenly the meter went off the scale and we both jumped a little. Then it went down to normal. We looked at each other and shrugged it off assuming it was due to natural energy floating around. Then it happened again. This took place about 5 times, each time with about 30 to 45 seconds in between. Interestingly enough this correlated with what a sensitive had "felt" earlier that evening before we even entered the location, when she mentioned the feeling of a woman walking or pacing back and forth in the upstairs area.*

John Zaffis states:

The salon investigation was one I went into not knowing the researchers at all yet, nor the history of the place, but it turned out to be a surprisingly good hunt that night. When the ghost came into the room upstairs with us, just about everybody had some type of experience with something. We encountered the most activity on the second floor and I know we had at least more than one ghost up there with us. We all walked away knowing that the building where Voila Salon operates out of was definitely haunted by several ghosts dating back many years.

13.

House with the Young Woman Rocking in the Chairs

A very pretty home along the tour gets many compliments from those visiting Roswell. This is a newer home built over a plot that happens to have a lot of history. Not surprisingly, an original millworker's home was there in the mid-1800s and was heavily reconstructed to be used as office space some time in the late 1990s.

One couldn't live in Roswell or nearby areas without hearing about this home and how the rocking chairs on the porch would rock by themselves. I myself heard these stories during the late '80s and early '90s. Since becoming an office space, no longer a private residence, there haven't been rocking chairs on the newly renovated front porch. Nonetheless, it appears as though the action of chairs rocking by themselves has not stopped on that property.

In the 1960s, a young woman residing at the home with her family was murdered by her boyfriend at a gas station in a neighboring city. In the late 1990s, this renovated site was used as an office for a group of lawyers. A young woman who was an employee in this office reported to us that all of the employees had seen newspaper clippings reporting the tragic death of the young woman who used to live there. These reports had included pictures of the murdered young lady, so they knew what she looked like.

Astonishingly, there were many mornings when these employees would walk into their offices and see their large leather chairs rocking behind their desks! On one occasion, the female employee mentioned above saw the apparition of the very woman who had been murdered in the

The renovated house where the young woman and the Confederate soldier are seen.

1960s. She was rocking in the secretary's chair, and after being seen by the employee, she vanished!

One evening, another female employee was preparing to leave for the day and was quite certain she was the last one remaining in the building. As she was about to exit through the front door she noticed that a computer monitor was on in the office to her left. The office's main light was off, but the large leather chair, whose back was to her, was pushed forward and upright, as though someone was sitting in it. Assuming her co-worker hadn't left yet after all, she entered his office and flipped on the light switch as she said, "What are you still doing here, and in the dark even!" Just as she finished her sentence, the chair spun around and she saw a man in a Confederate soldier's uniform in that chair. His eyes met hers and then he vanished.

That group of lawyers has told us that the person who worked out of that very office had many unexplainable issues with his computer. They found it humorous that this lawyer in particular, after hearing of the unexplainable activities and the apparitions being seen there, would state aloud that he didn't believe in ghosts. There were three separate times, just after these declarations of his, where he would come in the very next mornings to find that his entire hard drive had been erased! They hired and fired three separate companies that were brought in to find the reasons behind this

devastating problem of theirs. None of those computer companies found a natural reason for his hard drive to be erased like that.

One night in the summer of 2006 I was leading a tour group and we stopped in front of this building. At that time, the building was vacant as the lawyers' office had moved to another location. The large "For Lease" sign was in the front yard and all lights on the exterior and interior were off, except for a small light in the foyer behind the front door. The blinds were open, which allowed us to see into the office as we were looking at the front of the old house. The scant light from the foyer allowed just enough light to get a good look into that room from the sidewalk where we stood. I spoke of the mysterious happenings reported from those that worked in this location, and I noticed a small group of women were pointing in that window's direction and quietly talking to each other.

I finished my stories and continued on when one of the women scurried up to me and asked, "Are there Civil War reenactments taking place around here? We just love that sort of thing." I answered that there were none that I was aware of. She informed me of the fact that she and her sisters had just seen a man in a Confederate soldier's uniform pacing back and forth inside that office.

The very next weekend, I again stopped in front of this old home and the circumstances were all exactly the same. The small light was on in the foyer and the blinds were still open. I told the stories to the group and had completely forgotten about the previous week's sighting of a supposed Confederate soldier in the window. Again, just as it had occurred the week before, a small group began to point at the window and whisper to each other. I stopped telling my stories this time because I couldn't help but recall the previous week's incident. I asked them if everything was okay, and they said that they saw a man inside. I began to get excited, thinking that the tour groups were seeing the apparition of the Confederate soldier that the previous workers had reported. I hadn't said anything to this group about it and was a little deflated when one of the women stated, "He is wearing overalls." I thought to myself, how many different ghosts can this one place have? The young woman, the Confederate soldier and now a man in overalls?

When I remarked, "A man in overalls?" She said, "Well, that's what it looks like to me, because of these shiny buttons up on his shoulders." We all rushed to the window, and none of us, including the women who originally saw something in the window, saw anything at all. Indeed, it very well could have been the Confederate soldier she saw, and she just interpreted the buttons on the shoulders incorrectly.

14.

Flame Tree Glass and Chaplin's

M aureen and Lance McRorie, owners of Flame Tree Glass, which operates out of 470 South Atlanta Street, have attended the Roswell Ghost Tour. They enjoyed the tour very much and were eager to let us know about the strange activity they have in their store, which isn't far from the tour's route. They know little about the building's history, but have had much activity there. Maureen says she feels it is the ghost of a young, curious girl who really likes her husband Lance.

Lance does his glass blowing and artistic work at one particular station in a room toward the back of the building. He often feels that he is being watched as he goes about his work. Nearby, there is a sink with a coffee maker, various mugs, glasses and dishes. This sink has been known to suddenly turn on by itself, and a Tupperware bowl was seen flipping over, off of the counter, and landing about four feet from the sink.

In the front part of the store, there are various rods of glass covering all the colors of one's imagination. They are stacked neatly in various shelving units on either side of the store. The employees of Flame Tree Glass will often hear sounds coming from the glass rods as though someone is using his hands to roll them about. Items throughout the store are continually moved from places where they have been left.

The small shopping strip that Flame Tree Glass operates out of is not too far behind Barrington Hall. The street of newer homes that was built over the original property of Barrington Hall is directly behind Flame Tree Glass. It is believed that there was a church in the 1930s near here

Flame Tree Glass, a building believed to be built over an old cemetery.

Street of newer homes built on property that used to be a part of Barrington Hall's grounds.

and that the building that Flame Tree Glass operates out of is built over or very near that church's cemetery.

We arranged for Historic Ghost Watch and Investigation (HGWI) to come in and perform an official paranormal investigation of the building that Flame Tree Glass operates out of. HGWI is based out of the Atlanta area, and the team is highly respected in the community of fellow paranormal investigators. I'm proud to say that my husband and I are members. Michele Lowe, one of the team's psychic mediums, likes to go into investigations not knowing anything about the location. She avoids getting involved in any conversations about the current activity a given place is having, as well as its history.

At one point during the night, Michele pointed to an area behind the Flame Tree Glass building and stated she felt quite certain there was a gravesite there. This area she pointed to is in between the back of the building and where the street of newer homes is behind Barrington Hall.

Chaplin's Restaurant and Bar is across and up the street from Flame Tree Glass where it sits directly across the street from the east side of Barrington Hall at 555 South Atlanta Street. When in the restaurant after hours, the managers and employees at Chaplin's have repeatedly heard the sounds of an unseen horse and buggy. Additionally, items are often moved from where they were left in this location. Many of the restaurant's employees refuse to be on the premises alone due to the unexplainable occurrences and strange noises that abound there. They have heard that long ago the property their building sits upon was the site of Cherokee Indian burial grounds. It makes sense to them that they would hear the sounds of horses pulling buggies because that was likely how the Cherokee brought their dead there to be buried.

One night at Chaplin's, a manager was alone very late into the night as he tended to some paperwork in the restaurant's office. He heard banging around in the kitchen, distinct sounds of cabinet doors being slammed, as well as the ovens' doors being repeatedly slammed open and shut. Fearing a break-in, the manager ran into the room only to find that no one was there and the slamming noises had stopped. He does not work alone in the building any more following that night.

15.

Creepy House and Abandoned Restaurant

A few weeks before I officially took over as the main guide for the Roswell Ghost Talk Ghost Walk (as it was called at that time), I asked the previous main guide to meet me for lunch. We met at J. Christopher's, which is now in what used to be the Public House restaurant at 605 Atlanta Street. We had a delightful lunch as I enjoyed talking to Lisa in this atmosphere, taking the opportunity to pick her brain about various subjects after being a tour attendee myself during many of her tours.

As we were parting, she noted that I should try to find out more about a building that was three buildings over from where we had lunched. I knew the abandoned building she was referring to, and I asked her what she knew about it. She said she had a friend who had rented it and planned to open up her gift store there, but decided against it. She had just moved all of her merchandise in and hadn't hired any employees when, nonetheless, she noticed that items were moved from where she had left them. This was done in such an obvious way that Lisa's friend was certain it was being done by a resident ghost. Having lived with a ghost before, she thought it quite fine and that it could even be good for business once word got out.

It wasn't long before the store owner began to see things move on their own. She still felt that this would be no problem. Yet, before long, she saw items being flung across the room where they'd crash and break against the walls. There was also an instance when a porcelain doll flew across the room at her and broke before falling at her feet. It was at this time that she

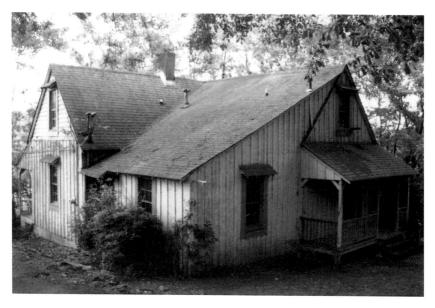

The long abandoned "creepy house" where many tour-goers have been witness to unexplainable sightings and activity.

The upstairs windows out of which the scraggly old woman and an angry-looking man have been seen staring.

realized this was not going to work out after all and she hightailed herself and her merchandise out of that building once and for all, opening up her store elsewhere.

After leaving the building, she shared what had happened with Lisa. Lisa did a bit of research and found that before her friend rented the space for her gift shop, it had been used for a beauty salon. She came across several women who had patronized the shop, and they all .d similar accounts. They relayed how they showed up for appointments they had made with the salon, only to find that the building had been abandoned. These women each noted how their feelings were hurt. They felt they surely were friendly enough with the shop's owner and their own hairstylists that if they were going out of business or simply changing locations, they would have been told about it.

And this is where Lisa left the story in my lap, to find out if anything else was going on at this abandoned, very creepy-looking old house. I would go to the property on occasion with my husband or a friend, and I can say that every single time I've ever stepped foot onto this property, I've gotten the willies. It takes a lot for me to say that, and I can say that there isn't another place in Roswell that has ever made me feel that way. It wasn't part of the Roswell Ghost Tour for a long time and was never part of the tour when it was Roswell Ghost Talk Ghost Walk. First of all, the tour used to only be an hour and a half long, and it was just far enough off of the tour's route that it was impossible to fit it in. Even after we took over the ghost tour and lengthened it to two hours to accommodate the newer stories of paranormal activity, I was uncertain about adding the "creepy house" as a stop for us. I truly felt that the energy was just negative enough to keep it from being a place that was regularly visited.

One night I had a group gathering in the town square to begin the tour when an adult woman introduced herself to me along with her parents. She and her father mentioned that the mother was a gifted sensitive but had a hard time embracing this gift. She had succeeded her whole life, for the most part, in ignoring her sixth sense. They said that recently though, she had become open to allowing her sixth sense to perceive what was around her. I remembered thinking that I hadn't visited the creepy house in many months at that point, and I briefly told the three of them about it. I told her I'd love to get her take on the house but wanted to make sure that she knew I called it the "creepy house" because it truly felt eerie to me. She assured me that she was game to check it out, and the rest of the group was excited at the prospect of seeing such a place that other tour groups didn't normally get to visit.

After telling the group what little I knew of the phenomena experienced at this location, the sensitive claimed she felt drawn to the other side of the abandoned house. We all followed her over there, and I recall that I directed my flashlight toward an upstairs window. I left it there for a few seconds, then directed the light to another window before bringing the light back to that first window. I had felt like it was time to move on, so I began to walk away from the building and the rest of the group followed. The sensitive then ran up to me and was crying hysterically. She said that when I had the light on the first upstairs window, she almost burst into tears but couldn't really describe why. When I took the light away from that window, the feeling subsided. But once I brought the light back to that first window, she did burst into tears. She stated that she simply felt so many overwhelming negative emotions all at once, including terror, loneliness, physical pain and sadness.

A few months later, as the night's tour group assembled, a woman introduced herself to me and stated that she was a sensitive. Throughout the night, she pointed out various things to me. She stated that Bulloch Hall most definitely had a very large number of ghosts. She said that the ghost of an old black man began walking beside us as we approached Founders Cemetery, only to say aloud, "You some crazy folks. I ain't walkin up there to that cemetery," and then disappeared in front of her eyes. At some point during the tour I mentioned the creepy house to her and how I'd recently had a sensitive over there who had experienced something profound that left me questioning my decision to take the group there. This woman begged me to take her there, and when the rest of the group heard of it, they wanted to go as well.

That particular night, my flashlight went completely dead as we approached the creepy house. It had never done that before, and it has not done it since. I told them everything I had told the previous group, about the two businesses we knew about that had tried to operate out of there. I chose not to mention that the previous group had gone to the backside because I didn't want to go back there with no light. The sensitive announced aloud that she was interested in going to the other side of the home and the rest of the group agreed. I stated that I wouldn't be going there due to the fact that I didn't have a light any longer. The rest of the group proceeded to look around, and in the dark I suddenly heard a woman calling out my name and asking where I was. I called out to her and she followed my voice until she found me. I have decided not to use her exact wording whenever I repeat this story because it is disturbing

to many that hear it. So I'm using general phrasing when I say that she ran up to me and stated that this was a house of severe child abuse. She then pointed to the same upstairs window that the previous sensitive had reacted so strongly to, and she stated, "And it was in that room up there." I had never mentioned what the previous sensitive had experienced, nor had I mentioned that she pointed out a specific window. In my mind, her account backed up what the other sensitive had experienced.

It wasn't long after that that I decided to go ahead and add this stop to the tour on a regular basis. Attendees had begun to ask if I'd be taking them there, so it was apparent that those that were on those two previous tours with the sensitives were talking a lot about it and sending their friends on the tour. I can honestly tell you that those experiences continue to be validated over and over again. I make it a point not to mention what others have experienced on the "other side" of the creepy house, yet accounts, details, sightings of apparitions in the windows, etc., all continue to add to the story and substantiate the other accounts. I had a young woman come to me at the very end of a tour back at the square to quietly reveal to me that she was an abused child. While there at the creepy house, she began to have memories that were not her own even before I uttered a word about the property. Other tour guides have been witness to tour attendees unable to step foot onto the property because they feel they will be physically ill. There have been many tour attendees who hear a loud whisper in their ear, telling them, "Get out!" I have received countless emails and calls from those who have attended the tour and later dreamt of the creepy house. They feel compelled to tell me that in their dream there is a young girl buried beneath this house. At the time of this publication, there have been at least a dozen children who have announced to us that they've seen a girl inside the home looking out at us with a very sad expression.

A well-known psychic/medium and paranormal investigator, Jason Lewis, recounts:

> When I was on the Roswell Ghost Tour we went to a house at the end of the walk. As soon as I approached this house I felt very uneasy. My feelings were very strong to not even go around this house. As we walked closer to the house I had the sensation of someone or something blowing in my ear and no one was close enough to me to do that. Not to mention that my ear hurt for two days afterward .

Although I have researched in all the places I know to look and have been unable to find anything that tells of the creepy house's history, I have met a man by the name of Thomas Tolbert who was born and raised in Roswell and has his own eerie feelings about the house. He recalls that when he was in elementary school in the 1960s, he would often walk from school to his dad's store in the square, which was in the old Public House building. Thomas would often take the route where he'd pass this house, which was a private residence at the time. A woman by the name of Maye Raven who worked at the Roswell Discount Store on the square would often pass him on the street. Every time they passed one another on that road, she would sternly tell him he should never look at that house. She never told Thomas the reasons for this odd demand, only that he was never to look at it. So Thomas got in the habit of always looking down at his feet or staring straight ahead whenever he passed this old house. Nonetheless, he always got a creepy feeling near that property, refusing to ever go by there at night, and still does today.

Not knowing where else to turn to find out the history of the house, I decided I would try to contact the leasing office that handles the property rental of the abandoned restaurant beside the creepy house. I assumed that when the person answering the phone heard that I was with the Roswell Ghost Tour, he would presume I was nuts and hang up the phone. Astonishingly, upon introducing myself and stating I was with the Roswell Ghost Tour, his first words were, "How did you know to call me?" I assured him I was only trying to find out some of the history of the little, old, abandoned, grey house that sat next to the empty restaurant they were listing. He was very helpful, as he knew quite a bit about the property's history. First of all, the abandoned restaurant and the abandoned house are both owned by someone that lives out of state. They are currently still trying to rent out the restaurant, which has been abandoned for five years. Whoever rents the restaurant space will also get the "creepy house" to be used as possible storage space. They are no longer trying to rent out the little grey house on its own anymore.

He also filled me in on the fact that in the realtor's office, the key to the front door of the grey house is labeled "Ghost House." It's common knowledge amongst those in the realty office that the house is haunted, as many of the realtors who have shown the house to prospects have had their own ghostly experiences. A full-bodied apparition has been seen in the upstairs window peering out at onlookers, even in broad daylight. She has long, scraggly, white hair and wears a high-neck blouse with puffy

Bandstand in town square where tour begins and ends. The bandstand is built over where a hanging tree used to be.

shoulders. She always has a very mean look on her face and seems upset that there are people at the property. There also have been sightings of an old man, equally mean-looking, who can be seen all throughout the house and appears as if he is daring the visitors to approach the home.

I found out that, supposedly, the bandstand where we meet to begin the tour in the town square is built over what used to be the town's hanging tree. Allegedly, the man who was in charge of all of the town hangings lived here in what we now call the "creepy house," and he and his friends would always come back here to party and celebrate after each of the hangings.

I told this gentleman at the leasing office that I found it very interesting that all of the tables in the abandoned restaurant were still set and that the dark blue water glasses placed upside down on the tables easily showed layers upon layers of dust. He mentioned that this was a common observation amongst those involved with the restaurant. It appears as though the previous inhabitants who had been operating the most recent restaurant in the space simply vanished in a hurry. He said that I wouldn't believe the number of dishes, kitchen equipment, antique furniture, linens, rugs and wall hangings that were abandoned there. He noted that anyone who has ever worked in the restaurant industry knows that tables

Inside restaurant where set tables are getting covered in dust after being abandoned for several years.

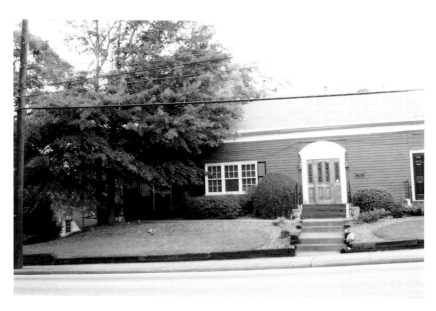

Front side of the abandoned restaurant. The creepy house can be seen through the trees on the left side of the photo.

This abandoned restaurant began as a home for the town's doctor. He kept his horse in the area beneath the house during bad weather, and he would ride the horse to make house calls.

Creepy House and Abandoned Restaurant

would not be set with all of those details if they knew they weren't going to be welcoming and serving patrons the very next day. Each table is still set with cloth napkins, silverware, water glasses, salt and pepper shakers and sugar packets, all of which are now caked in dust.

We do know some history of this particular building. It first appeared as a home on an 1871 survey map. It was built for Dr. T.R. Greer by patients who did not have the money to pay him, so they built this h_ _e for him instead. Also surrounding this property was a barn, grain bins and a smokehouse behind the home. During inclement weather, the doctor would stable his horse in the basement—this area underneath the side of the building can still be seen. He would ride his horse to make house calls for Roswell residents. Between the years of 1918 and 1925, Officer Holmes, who was a foot patrolman in downtown Roswell, lived in this home, and the root cellar sometimes served as a jail cell.

While representing the Roswell Ghost Tour at a networking meeting one afternoon, my husband was approached by a woman who had worked in this particular building when it was one of its many restaurants. She stated that she had an undeniable paranormal experience in the basement there and she refused to ever return. One of the old jail cells in the basement was being used as dry storage area. She said that the iron bars on the door to the cell could still be seen. Many of the restaurant's employees had mentioned that the building was haunted and that strange happenings occurred in the basement area. She was instructed to organize the storage area one morning and not being a believer in ghosts, she proceeded to spend an hour organizing the contents in this old jail cell in the basement. She stepped out of the small space into the hallway to take a sip of her soda that she had left on a chair there, which took her just a few seconds. She set the drink back down, walked back into the room to finish up her final touches to the storage room and shockingly saw that the room was as it appeared when she first entered it—before spending an hour organizing it. She fled from the building and swore she would never return to it.

16.

Public House and Adjoining Buildings

The Public House restaurant was a beloved upscale restaurant here in Historic Roswell for many years, particularly in the 1980s and early 1990s. It operated out of a historic, very haunted building that was built in 1854 and used as the town's commissary, carrying most all of the necessities for the town's families at that time including tonic, wine, sugar and sundries, but not liquor. The Roswell Manufacturing Company is said to have monopolized the trade in all general supplies. However, times became very difficult during the Civil War and clothes and food were in short supply. The people had useless currency; most everything purchased had to be paid for with edible goods such as chicken, meat, eggs and flour. Desperate families gathered early at the mill store in hopes of purchasing some of the small amounts of thread the company would sell for cash. Long lines formed creating a mass of angry people outside the doors of the store. Often, families were starving, sacrificing the food items they had to get the bare minimum they needed to clothe themselves.

Although no official documentation can be found on these two, the legendary story of Catherine and Michael is well known throughout the South, and the paranormal activity at the old Public House restaurant building has been blamed on them for many decades. Their story has been featured on numerous documentaries that have been aired on the Travel Channel, Learning Channel, Discovery Channel, History Channel and also an episode of *Unsolved Mysteries*.

The old Public House restaurant, now J. Christopher's restaurant.

View from upstairs in the old Public House restaurant. Possibly the view Catherine had when she witnessed her lover being hanged in the square.

There are a few differing stories regarding the duo. One reports that the old commissary became a hospital for wounded soldiers during the Civil War and that Catherine was a nurse tending to those soldiers. Michael was a Union soldier, and he and Catherine fell in love during the time that she tended to him.

Another story states that Michael was actually struck by lightning and his body washed away in a terrible storm never to be heard from again. In that version of the story, Catherine disappeared a few days after his death never to be seen or heard from either.

The story that is told most often though is that Catherine, at the age of seventeen, worked at the commissary and that her father owned the business. In July of 1864, she was working the front counter when Michael, a seventeen-year-old Union soldier from Ohio, walked into the commissary where he saw Catherine for the first time and they both fell in love at first sight. Legend has it that they had a very open romance, which of course was unheard of back then, especially since it was a love affair between a Northerner and a Southerner. Unfortunately, their relationship was very short lived because Michael was charged with treason, presumably because of this very relationship, and he was hanged in the square just a few weeks

The piano upstairs that often plays by itself.

after their initial meeting. Catherine saw the hanging from upstairs in the commissary's building where it took place just across the street. According to this long-standing legend, Catherine hanged herself from one of the large beams that can still be seen today upstairs in that building, exactly where she stood as she watched her love get hanged himself.

Whichever story is the correct one, it appears that Catherine and Michael have returned to this place to find one another and share their love the way they would have liked to all those decades ago. They are routinely seen within the walls of the old commissary. Many report that while standing in the town square they see the two of them dancing through the upstairs windows or sitting in chairs looking out over the town, perhaps imagining the way the town square was back in their day. Many people also have seen a large, lit candelabrum being held as someone walks within the upstairs room, but no candelabrum currently exists inside today. Employees have reported that large chairs surrounding the grand piano upstairs appear to have been moved overnight so that the two can do their dancing around the piano.

The grand piano remains in the upstairs area where the Public House's piano bar operated, and that piano occasionally plays by itself. When the employees of the current restaurant, J. Christopher's, have walked

The main bar upstairs in the old Public House building where much unexplained activity has been witnessed.

upstairs to investigate the piano's sounds, the playing stops as they enter the upstairs area and notice that the cover to the piano keys is closed.

A bartender who worked the upstairs bar while the Public House restaurant was still operating had a hair-raising experience while there late one night. It had been a long, busy night, and the only ones who remained in the building at that time were himself and the restaurant's manager. The manager could still be heard downstairs while the bartender took on the task of drying the many glasses and hanging them at their place above the bar. He finally finished that task and walked to the small office behind the bar to get his keys as he was anxious to get home. He said it probably took him eight seconds from the time he headed into the office to the time he passed back by the bar to leave, but to his astonishment, as he walked by the bar he saw that each and every glass was standing upright back on the bar's counter!

There were many times when the bar staff returned to the restaurant to begin a shift only to see that at some time during the night, the liquor bottles had all been turned backward. It became routine for them to check on the bottles before their shifts started, as they often had to rotate the bottles so that the labels faced out. Also, many times they would put

The wooden beam upstairs in the old Public House restaurant building where Catherine purportedly hanged herself.

the chairs on top of the tables and before they had even left for the night, several or all of them were back down on the floor. Or, they would return the next morning to prepare for the lunch crowd and some of the chairs would have been placed back down on the floor overnight.

Michele Lowe, who is a paranormal investigator as well as a sensitive, works with Historic Ghost Watch and Investigation. Below she recounts her experiences during a formal paranormal investigation of the building, as well as those experienced while in the building as a patron of the restaurant.

> *I have had a few experiences at the Public House, now J. Christopher's. My first was with Dr. Hendler, the doctor I work for, and one of the drug reps who took us out to lunch there. They were always very hospitable and let us go upstairs to take a look around. Dr. Hendler and I both had heard it was haunted. While we were upstairs a cold air came and circled around me and over Dr. Hendler, whose hair stood up on his arm! We then decided to go back downstairs and the cold air actually followed us back to our table.*

Michele continues:

> *I was there again with Dr. Hendler, Jamie a co-worker, and another drug rep. As we were leaving the restaurant and already outside the building, actually where you go down to the parking area, one of the upstairs blinds covering the windows started slamming the window extremely hard, and no one was behind the window. I turned to Jamie and I said did you see that? She responded she did. We were both glad that each other had seen it!*

Over the years, most employees who have worked in this building have avoided being in the upstairs area as much as possible. They often report a feeling of heaviness, negativity, unexplainable sounds and items that have mysteriously been moved. Many servers have noted that they will suddenly hear the sounds of Catherine's body swinging from a rope from one particular beam in the ceiling where they believed she hanged herself. They will even point out the groove in that wooden beam. Others report that they often hear sounds up and down the stairs, stating it sounds like Catherine's big taffeta dress material rustling against the stairs as she moves about.

A few years ago, a manager had to be hired very quickly as a replacement for the previous manager of J. Christopher's. This was due to the fact that that previous manager abruptly left the building one Sunday afternoon and

A previous J. Christopher's manager was sitting in one of these chairs when she saw a man in a Confederate soldier's uniform begin to appear.

refused to ever return. She recounted her story via a telephone conversation to explain her impromptu resignation. It was a busy Sunday, as usual, and she took a moment to relax in one of the large wing chairs in the upstairs area. This area is not utilized for the general customers, so it was a good place to escape from the crowd downstairs. She laid her head back and closed her eyes for a few minutes and suddenly heard the springs in the chair next to her. She opened her eyes expecting to see a server or someone else also sitting to take a break. There was no one there at all, but a downward impression was slowly forming in the chair's cushion. It was then that she saw the apparition of a man in a Confederate soldier's uniform beginning to materialize, his face looking directly at her. This is what sent her screaming from the building refusing to ever return.

This Confederate soldier is routinely seen as well. It would be interesting to find out his history, who he was and why he remains at this place. It would also be interesting to know if he and Michael, the Union soldier, are aware of each other's presence here.

On another occasion, a past female employee of this restaurant came to the building on an off day to collect her paycheck. She had her four-year-old daughter with her, and as she climbed the stairs to get to the upstairs office, the daughter asked if she could wait for her at the bottom of the stairs. Her

mother gave her permission to sit at the bottom of the stairwell and wound up getting involved in a conversation in the office with another server. Several minutes later, when the mother began to descend the stairway to leave, she noticed her daughter appeared to be talking to herself and was quite animated and happy. As she approached her daughter, she asked the girl who she was talking to. Her daughter exclaimed, "Aww Mommy. You just scared away the nice man. He had a neat costume on, with buttons everywhere." Knowing full well about the Union and Confederate soldiers' ghosts, she wondered if her daughter had encountered one of them, and if so, which one. When they arrived home, she searched for pictures of the soldiers' uniforms online. Just as pictures of each of the uniforms were on her computer monitor, her daughter walked in and pointed to the Confederate soldier's uniform, exclaiming, "That's that neat costume the man at your work was wearing today!"

For some reason, the ladies' bathroom is quite active. We are told that the current bathrooms will be renovated soon, so we anticipate that the activity will increase during that time, and we're looking forward to finding out if that theory holds true. Currently though, there are two stalls in the ladies bathroom just beyond the area where the sinks and mirror are. We have heard from many women that they will be sitting in the stalls when suddenly the hook-and-latch lock has lifted up and the doors have flown open!

It appears as though Catherine is not the only woman who haunts the restaurant. When Catherine has been seen, she is a young woman with long, dark hair wearing a blue dress. Several women have told us that while they were alone in the bathroom washing their hands at the sink, they looked up in the mirror and suddenly saw a woman standing behind them. Each of them spun around only to find no one there. When asked for a description of this woman in the mirror, each of them stated that she appeared to be in her mid-forties and had short, blond, curly hair.

One of the cooks has reported that he was the first to arrive to the building early one morning, as he most often is, and he began his work cooking in the kitchen when he saw a woman walk by. He stated that it appeared as though she was leaving the back hallway where the bathrooms are located and entering the main dining area. Perplexed as to how someone could have gotten into the locked building, he rushed out to approach her to find out who she was and what she was doing there before the restaurant was open. He found no one. Other mornings, he has arrived at the back door that enters the hallway leading to the bathrooms (the employee entrance to the building),with his key out ready to unlock the premises, only to be

Vault door in SODA Salon that leads to the safe that remains here from when this building served as Roswell Bank in 1917.

stopped in his tracks by the sounds of knocking coming from the inside. Each time he has refused to enter until others show up to enter with him. They never find a source for those knocking sounds.

There are other parts of this building that were added on in the early 1900s. Various businesses operated out of these other connected areas, which included at one time or another a funeral home, shoe shop, post office, telephone exchange, feed warehouse, pharmacy and soda shop, theater for silent movies, department store, antique store and a bank. The Roswell Bank was incorporated in March of 1901. It was intended to serve the payroll and bookkeeping needs for the Roswell Mill. The operating area of the Roswell Bank was enlarged in 1913, and a large bank vault was added at that time. This portion of the building was later used for other businesses for a few decades such as the drug and soda company, post office, funeral parlor and silent picture theater. In 1973, the president of Historic Roswell Inc., Richard S. Myrick, purchased these buildings and restored them. Imagine his surprise when he found $600,000 in Confederate currency and $500,000 in bonds as he was cleaning the area above the still-usable vault. The bonds were made out to the Roswell Manufacturing Company and Barrington King. Myrick speculated that they probably were in payment for goods furnished to the Confederacy.

Longtime Roswell resident, Thomas Tolbert, whose family has lived in this city for five generations, fills us in on some spooky accounts. He heard of many as he grew up in Roswell. His dad had a mattress store over what is now SODA Salon. Downstairs was the Roswell Department Store and the front sidewalk was always lined with rocking chairs. Both white-collar and blue-collar men would sit together in these chairs as they watched the traffic go by between them and the town square. He remembers that the main road was only two lanes, as opposed to the four lanes that it is today. Thomas spent many hours sitting with the men in those chairs and heard all of their tales. He says that they'd speak of ghost sightings, often of ghosts seen in the very building they sat in front of, but spoke of them just as nonchalantly as if they were talking about the weather. One such story Thomas recounts is of a piano player who played during the silent movie era. The theater was upstairs next to his dad's mattress shop. It was often told that the piano player would complain of extreme cold spots whenever there were solemn moments in the film's story line. Also, a Confederate soldier's ghost was oftentimes seen wandering throughout the building. This may

SODA Salon and Fired Works.

not seem to surprising as right next door to the theater is where the Roswell Funeral Home performed their embalmments.

One portion of this historic building currently houses Fired Works. It's a place where customers can paint their own pottery as well as a store to find beads of all sorts for jewelry making. The owner, Linda von Seggern, and her employees report some activity in their shop where the original wooden floors are underfoot. She opened her store in this building in the fall of 2001, and it wasn't long before she noted that it appeared older residents were still lingering within these walls. Linda recalls a time when she entered her shop one morning to find a mirror had apparently fallen off of the wall and shattered. What was odd though, was that the nail was still firmly intact in the solid concrete wall. It had not broken off, nor had it fallen out, nor was it bent downward. Also, she noted that the frame with the shattered mirror was still intact, and the wire on the back of the frame that held it on the wall was still intact. Stranger still, was how it rested. The frame, with glass shards all inside it, was resting on a table and partially over the back of a chair that were at least five feet away from the wall where it had been left hanging. Since opening her store, she has been perplexed as to why her kiln occasionally turns itself off if left unattended. She states that usually there is an indicator that tells her if there is an electrical outage or problem, but on these occasions, it simply turns itself off.

The shopping strip on the Roswell Town Square.

SODA Salon currently operates out of the end of this building, where the bank and funeral parlor once operated. They report various unexplainable experiences as well. The old Roswell Bank's vault is used as storage, and most of the employees state that they do not like to go in there. Also, a bathroom that is located close to the vault is another locale the employees try to avoid. Whenever they enter either of those places, they speak of their hair standing on end, feelings of being watched and intense cold spots. Interestingly enough, that back bathroom was the same area where the funeral parlor's employees would move the dead bodies through to the waiting hearses in the early 1900s. The bodies were embalmed upstairs and put into a casket. The caskets would then be taken to the elevator, which was located over the bank, and then lowered to the ground floor. It was then that the caskets were taken through the short hallway, out the rear door of the bank and to the waiting hearses.

In general, the employees claim they prefer to use the "buddy system" within the building, never liking to be in the building alone, particularly after dark. This can also be said of the employees of the previous business that operated out of this area. In the mid-1990s, it was used for an antique furniture store and the employees there said that items were routinely moved from where they had left them. One young man was in the office late at night by himself. He wasn't there for very long, but he remembered leaving his keys

on a front table as he entered the building. As he prepared to leave, he passed back by that same table and his keys were nowhere to be found. He hunted all around, looking first beneath the table to see if they had fallen, and then around the room, but he couldn't find them. He entered an entirely different room that he hadn't even been in at all that night, planning to use the phone there to call a family member for assistance in getting another key to his car. He stopped in his tracks when he saw his keys on the desk next to the ph. ne in this room that he hadn't stepped foot into.

In the fall of 2003, SODA Salon began preparing the location to open up for business. An electrician was on the premises alone as he was doing some work high up on a ladder. He had a box beneath the ladder with various items that an electrician would need, including bulbs, wiring and a voltage meter. As he stood atop the ladder tending to his work, the meter started going wild, lights flashed and loud beeping noises came from the instrument. The electrician jumped down and verified that it was not attached to anything. He stated aloud, "If that was a ghost that just did that, do it again." The meter made no noise and didn't light up again, so he climbed back up the ladder, and as he did he said aloud, "That's what I thought, you're a cowardly chicken." Then the meter suddenly began lighting up and making noises even more than it had before. The electrician immediately left the premises at that point. He has since come back to do more work, but insists that he not be alone and that it's before dark.

Erin Richardson has been a stylist working at this salon since it opened its doors and recalls that she, along with owners Tracey and Eric Pearson felt there was something eerie about this building. They have routinely seen shadows out of the corners of their eyes, only to look and have them vanish. Obvious cold spots are felt for no apparent reason throughout the shop. Sinks have turned on all by themselves, glasses will spontaneously break by themselves and the strong smell of roses is noticed by all, despite there being no source for that strong smell. They note how interesting the smell is and wonder if it's a residual smell from when the building was used for a funeral parlor.

17.

The Dom House

This home is not along the Roswell Ghost Tour's route and is not a part of the Historic Mill Village, but upon learning about it just days before submitting this manuscript, I felt I would be remiss if I didn't include a chapter about the Dom House.

This home was built in the very early 1900s on the Chattahoochee River and is only a mile or two from the town square. Originally, timbers were floated down the river where they were brought to the property and used in building the house. It is very well known around town and older Roswell residents easily recall that this was referred to as the Dom House since the Dom family had built it and lived there for many years. The home has some strange stories connected to it's origins. In the 1920s to 1930s, the family raised alligators here. Many were even kept down in the basement, and Mr. Dom was known to sell the baby alligators. When the city found out and came to shut the Doms' alligator business down, they found that the Doms had released every last one of them into the Chattahoochee River prior to their arrival.

I met with Tyra and Steve Vasche at the Dom House, which has been their home for twenty-five years. Tyra used to be Tyra Coleman, a name that is well known around Roswell where she was born and raised. I myself live off of a road named after the Coleman family. Tyra recalls that when she moved her young children to this home, everyone thought she was crazy. It was in the middle of nowhere at that time and was in terrible disrepair, not to mention the reputation the home had. It

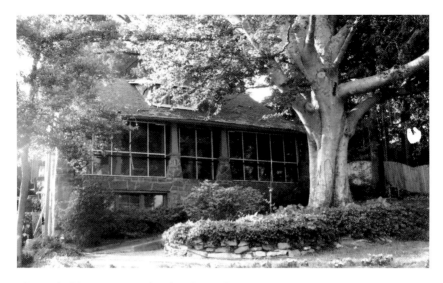

The Vasches' home, commonly referred to as the Dom House.

was common knowledge that every woman who ever lived in this house wound up dying within those very walls. Most were by natural causes, but one woman in the Sullivan family in the mid-1900s hanged herself above a well that was right in the middle of the home's kitchen.

Tyra purchased the home and signed the "document," a brown paper bag, in the back of a truck bed in front of the house. She hadn't even looked inside but decided this was home, purchasing an acre and a half of the property with it. It's strange for her to think of it now, as she grew up referring to this house (as everyone else did) as the "spooky house on the river." Tyra is now in her late fifties and recalls that when she was in high school, the now very busy street in front of her house was a dirt road that led to an area up the river where moonshine could be purchased.

Once Tyra signed and got inside of her home for the first time, she knew she had her work cut out for her. Her own mother took her kids away from that house for nine months until Tyra got it in a condition where it was fit for children to live. She said the homebuilders must have been left-handed due to where the light switches were placed. Many stained-glass pieces are still in the house, and it has been discovered that each of those pieces was purchased out of a Sears, Roebuck and Company catalogue at one time. Sadly, before Tyra moved in, the previous owner's first wife was found dead in the pond just yards from the home. She was pregnant at the time.

The Vasches' kitchen where a well once stood.

Tyra and Steve have vowed to never move from this home and hope that their children will care for this house that is now cherished by everyone who visits. They have hosted weddings for their children on the front lawn. The couple has put a lot of love into the home, with their positive energy, the love of a close family and the effort of keeping the home maintained. Steve is a talented woodworker who uses every downed tree on the property to create molding, doorjambs and whatever else may need replacing within the home.

Tyra recalls that the very first day she entered the home, she saw a ghost. It was a slim, elderly woman with her grey hair tied up into a bun. She had on a white, high-necked shirt and just stared at Tyra. Tyra never felt threatened or scared, and as the months went on, she routinely saw this ghost out of the corners of her eyes as she worked throughout the house. Eventually, Tyra decided it was time to give her a name, so she began to refer to her as "Martha." When Tyra's daughter was twelve years old, she was asleep in her bed one night when she suddenly awoke to see a woman standing at the foot of her bed. She asked her mother who that woman was. Knowing full well that no other woman was in the home, Tyra asked her daughter what this woman looked like. Her daughter described the ghost that Tyra had seen so many times before.

Today in this same bedroom, after Tyra's children have grown up and have had children of their own, it is a peaceful room. Used as the family's guest bedroom now, all who stay here report that they get the soundest

The guest bedroom in the Vasche home where the ghost of Betsy or "Martha" has often been seen and felt.

"Mother" headstone that was found in the Vasches' basement.

Sidewalks like this one have been found by the Vasches while digging in their yard.

sleep they have ever had. Most visitors claim to feel Martha's presence here, and it's very positive and calming. Others refuse to stay in this room, including Tyra's own mother, even though Tyra assures them that Martha is a friendly spirit. Interestingly, whenever there are times that the rest of the house is very hot, this bedroom constantly stays cold.

In 1992, Steve Vasche was building a room over the kitchen. He left the area to tend to some visitors outside and forgot about a light he had 'ft on. Tyra and Steve came home later that evening, and Tyra stated that she smelled smoke. Steve checked out everything and didn't see a reason for the smell, so they disregarded it. The couple was sound asleep in their upstairs bedroom when around 3:00 a.m. Tyra felt a hand firmly nudge her shoulder. She woke up and saw that her cat was on her stomach and was making an awful noise. She realized the cat was having a difficult time breathing and was making coughing noises. She turned on a light to check on her cat, and it was then that she saw that white smoke had filled their room up level to the top of their bed. All were able to get out safely, and Tyra attributes their safety to their ghost who woke her up just in time.

Tyra and Steve decided to host a Dom family reunion at their house in 2000. Upon hearing the guests' stories of the strange occurrences they had experienced or heard of in the home, Tyra began to tell them of her own. She even went so far as to describe what the female ghost, whom see continually sees, looks like. A woman in attendance pulled out a photo of her great-great grandmother who died in this home, and to everyone's astonishment, Tyra pointed to the picture and told them that this was the woman she had seen in the home on numerous occasions. The family informed her that her name was Betsy Dom, but Tyra still likes to refer to her as Martha.

Deep in the Vasches' basement, headstones have been found. While it was alarming to find them, they found out from the Dom family that their ancestors used to make headstones for the Roswell Funeral Home. The very first body to be embalmed there was Mr. Dom, but the family couldn't afford to pay the funeral home. In payment, they made headstones and fire irons for the funeral home and continued the business afterward. Tyra has since placed one of the headstones that was found in her basement, which says "Mother" on it, in her side garden. As they've dug around their yard over the years, they've come across brick walkways that they've cleaned up and use to this day. They've also found kerosene lamps and many tiny medicine bottles that they proudly display throughout the house. The Vasches had hoped to get their hands on the old fire irons to put back in their old home, but no one knows what happened to these handcrafted fire irons that were once in the old Roswell Funeral Home.

Conclusion

Thank you for taking the time to read about my "chosen" city. My family and I have fully embraced all that Roswell has offered us. We appreciate where it began, the rich history both good and bad, and we don't take for granted for a second that we live in a wonderful city that cherishes it's past, present and future.

As for the ghostly tales, I do believe with utmost certainty that this city has paranormal activity. Few of the stories are frightening—a surprising number of Roswellians state that they live rather harmoniously with their ghosts.

There are many other beautiful, historic homes and buildings within Roswell's city limits that we know report paranormal activity. I chose to mainly focus on the Historic Mill Village, where we concentrate our Roswell Ghost Tour. Even though I am able to write an entire book just on the Historic Mill Village and include a few locations immediately surrounding it, I am certain we only know the tip of the iceberg when it comes to all that goes on here. Please come pay us a visit sometime, and I would bet that we'll have some newer stories to report for you.

About the Author

Dianna Avena has had a lifelong interest in the paranormal. She grew up an air force brat and has lived all over the United States and overseas. When Dianna was five, her mother had a near-death experience during a routine surgery and relayed her experience to her young daughter. As a result, there was never a time in Dianna's life when she doubted that there is more to what we see here in our black-and-white existence on earth.

Dianna planned a life as a physician, but in college found she continued to be drawn to stories of miracles and unexplained phenomena.

Photo courtesy of Richard Mellinger.

In the fall of 2000, she attended the Roswell Ghost Tour in Roswell, Georgia, her current hometown of eighteen years. She was intrigued

by the paranormal phenomena occurring in the historic area, and she fully embraced her curiosity of all things paranormal at this time. She attended the tour many more times after that and became the main tour guide shortly thereafter. She and her husband, Joe Avena, purchased the tour in the fall of 2005 and have made Roswell Ghost Tour very successful, garnering national attention. It is led by paranormal investigators who have a love of Roswell's history and a respect 'or paranormal research and its integrity.

Dianna has investigated alongside many of the nation's well-known paranormal investigators. In the fall of 2007, Dianna realized the best way to reach her goal of furthering the general knowledge in paranormal research was to found and direct her own paranormal research team, so she founded Roswell Georgia Paranormal Investigations (www.roswellparanormal). Her paranormal dream team was announced as a Georgia representative for the Atlantic Paranormal Society (TAPS) in January 2008.

In May 2008, Dianna was announced as a co-host of the *After Twilight Radio* show. In September 2008, she co-hosted the national paranormal convention Univ-Con 7, alongside Chad Calek of Steven Spielberg's *Rising*.

Outside of her paranormal interests, Dianna has been an actress/model/body double/stunt double since 1992. She is a proud mom to three active boys and loves to cook and bake, having published a cookbook of her family's favorites. Her other interests include scuba diving and belly dancing.

Visit us at
www.historypress.net